Published by Tate Publishing & Enterprises, LLC
127 E. Trade Center Terrace | Mustang, Oklahoma 73064 USA
1.888.361.9473 | www.tatepublishing.com

Tate Publishing is committed to excellence in the publishing industry. The company reflects the philosophy established by the founders, based on Psalm 68:11,
"The Lord gave the word and great was the company of those who published it."

Published in the United States of America

ISBN: 978-1-62147-354-1

1. Art / Subjects & Themes / Religious
2. Religion / Christianity / General

12.04.04

The Life of Our Lord
Paintings

&

Inspired Explanations
of the
Holy Trinity

As I discovered Jesus by

Pierre Bittar - 2011

(Mark 16:15) "Go into all the world and preach
the Gospel to all Creation."

Jesus

Content

Acknowledgement

I give thanks to you O' my Lord for your generous blessings.

I was 10 when I wanted to be an impressionist artist and you granted it to me.

Now in my old age I want to spread your Word and you also allowed me to do this by using the talent that you granted me.

Thank you for directing my hand while painting your life on Earth.

Thank you for showing me an easy and simple way that allows faithful believers to also spread your word.

Thank you for helping me with writing this book.

To you all the praise and the glory.

Introduction

I have always had in me the desire to share my knowledge, feelings, and faith.

When I was starting out I made my living as an instructor at the European Education Center of NCR in Zurich, Switzerland. After five years, I was promoted to the position of education director of NCR in France. Teaching for me was a means to share my knowledge.

At the age of 46 I became a full-time artist thanks to the talent with which God blessed me. Painting has allowed me to share my feelings.

Now in my old age, my desire to share my faith with others has pushed me to ask God in my prayers to use me for spreading His word.

We are living in an age in which more people are turning their backs to God. The absence of God and His word from schools and from our daily life is obvious. The abolition of everything that reminds

people of God, such as the restrictions in schools against teaching the Bible, or praying in public, is transforming our society and turning upside down our values and beliefs. The Devil and his followers must be working very hard these days. They are not limiting their efforts and attacks to only the younger generation, but they are also spreading all kinds of doubts into the minds of believers of older generations to weaken and destroy their faith. We also cannot ignore the genocide of Christians by the enemies of God that is increasing every day. The suicide bombers are devastating churches and killing thousands of Christians in Africa and the Middle East.

Churches are doing the maximum they can do within their means. Christian TV channels are also doing a great job by using the advanced communication system of satellites to spread the word of God all over the Earth.

It is without a doubt a spiritual war between God's people and the followers of the Devil. God's

people are trying to convert a maximum number of unbelievers to Christianity. And the Devil followers are doing their best to destroy the faith of believers and convince all others that God does not exist.

Many believers are aware of this situation. They would love to be able to participate and convert as many unbelievers as possible to God. They know that their contribution is necessary. They know that as Christians their mission is to spread the word of God, but they feel powerless because of a lack of solutions, a lack of means, a lack of time, a lack of energy, or a lack of mobility caused by sickness or disability. God is very merciful; He will never abandon those who are faithful to Him. He is great and He always has great solutions.

I was praying to God to help me find a way to spread His word (see Chapter 1, F). It was in January 2011 that God commissioned me to paint "The Life of Our Lord" (see Chapter 4).

The most amazing part of the story was when He woke me up on that Saturday, August 20, 2011, at 3:15 a.m. to give me a new message which will allow those faithful believers to be able to participate in spreading His word to millions of people in a few seconds and without too much effort or cost.

God does not abandon His people.

In November 2011 I was inspired to translate my website to 17 additional languages, allowing billions of people around the world to have the opportunity to discover Him and to believe in order to be saved.

In December 2011, God inspired me to explain the most complicated subject, which is the Holy Trinity. This inspired explanation is in Section II of this book.

Section I

Chapter 1

My Relationship With Jesus

A) My First Experience With Jesus

I have had a very good and intimate relationship with God. I remember one day, at the age of 11, I was attending my daily Catechism class in school like every day. The subject was the Humiliation and Crucifixion of our Lord. While He was hanging on the Cross, nailed by His hands and feet, after all the humiliation that He had endured, the blood that He lost from the crown of thorns planted on His head and the flagellations with a metal tipped whip on His back and shoulders, He was thirsty. Instead of water, the cruel Roman soldiers gave him vinegar. At that young age I was sad and disgusted. So when I arrived home after school, I went to the kitchen, pulled out the

bottle of vinegar from its cabinet, and drank out of it.

I had forgotten about that incident which happened 66 years ago. But not long ago I was looking to my past, what I was and what I have become. While I was counting my blessings, I asked God in my prayers, "Why was I so blessed?" He, through a vision, reminded me of what I had done for Him when I was 11.

From my life experiences, I learned that if someone loves Jesus by following His commandments and believes in Him as God and Savior he can, in the case of difficulties that he cannot overcome, ask for Jesus' help and he will receive more help than he was expecting.

As we can read in Proverbs 3:5-6: [5]*Trust in the LORD with all your heart and lean not on your own understanding; [6]in all your ways submit to him, and he will make your paths straight.*

B) God Does Not Forget Our Prayers

I was 10 when I wanted to be an impressionist artist. I loved impressionism so much that during my teenaged years I spent my leisure time in museums. I sometimes spent hours studying one single painting. I was already painting at that age. My only desire was to become an impressionist artist, having people admire my work and be moved as much as I was by the paintings of the masters. God heard me and knew about my strong desire. But nothing happened until I reached the age of 46. Jesus knew that it could not happen in my youth. He knew that my father would pass away when I was 18. He also knew that my mother would need support. My two older sisters had to work and so did I. My younger brother and sister needed to finish their studies. We were not wealthy and we did not have any inheritance.

I started to paint at the age of 10. I have not stopped painting since then. When my father

passed away my mother did not have enough money to have a private tomb, so she had to bury him in a paupers grave, and this caused her to grieve much. This moved me and I started preparing an exhibition with the hope that I could sell my work and assist her financially. In 1956 I was ready for the first exhibition of my life. It was successful enough to buy a private tomb for my father.

When I finished my high school degree, I noticed that God had gifted me with a mathematical and logical mind. He also gifted me with a great ability to teach. God was very generous to me. So I used these qualities by working in a computer company, which at that time was still using the punch card system. I was 19 and enrolled in a night class at the academy of art. I was experienced enough that I was immediately promoted to a higher class, and I finished my degree by winning the first place prize at my graduation.

I then went to work for the American international computer firm NCR. I was employed as an instructor at the NCR European Education Center in Zurich, Switzerland. I was already married at that time. My job was to teach NCR sales people, as well as programmers, for all of the European countries. I also had to teach in other countries like Lebanon, Turkey, and Tunisia. It is also in Switzerland that my two sons were born. My teaching skills brought me back to France and gained for me the responsibility of creating the NCR French education center where I became the Education Director in 1965. I was 31. All the praise and glory belongs to God who blessed me to become what I am.

My business and family responsibilities were no obstacle for my painting. I had my weekends, holidays, and vacations to practice and use the talent that God blessed me with. I participated in many local and national art competitions and I gained many awards and gold medals. I

never gave up on my dreams. I was preparing myself to be what I had always wanted to be; an impressionist artist. I started to build up a press book, took photographs of some of my paintings, collected magazines and newspapers articles about my shows, and saved art critiques in regard to my impressionist style.

Time was passing by and I wondered when my dream of being a full time artist would come true. It would be not easy for me to switch from a secured, well-paid position to become a starving artist. I had a condo with a mortgage to pay and two young boys who had to finish their studies. I felt that I couldn't, by myself, get out of this situation. So I prayed this inspired prayer that I use whenever I have difficulties that I cannot solve.

"Dear Lord, keep my branch attached to your vine and fill me with your wisdom."

I was inspired to use this prayer from John 15:4, 5, 7:

⁴Remain in me, as I also remain in you. No branch can bear fruit by itself; it must remain in the vine. Neither can you bear fruit unless you remain in me. ⁵I am the vine; you are the branches. If you remain in me and I in you, you will bear much fruit; apart from me you can do nothing. ⁷If you remain in me and my words remain in you, ask whatever you wish, and it will be done for you.

One day, I was at the photography studio with a new painting to be shot. I also had my press book with me. In the corner of the waiting room, an old man was sitting. He was looking at my new painting. He asked me if I had other paintings in the press book that I had with me. I always carried it with me in the event someone would be interested. You never know. So I proudly and gladly handed him that book. He spent some time studying it and then he said, "You should display

your work at the Salon Des Artistes Français." I replied that I had already heard about the Salon and other artists had told me how difficult it was to be accepted. Many of them had tried and been refused. They told me to be admitted one had to present themselves with up to three paintings to a committee of 21 jurors. The decision is taken by vote, and only if a painting gets the majority vote of a minimum of 11 out of 21 will it be accepted.

The old man listened to my recitation. When I finished he introduced himself as an artist who had previously won the gold medal of the Salon. He encouraged me to try anyway and said, "If they refuse your painting, do not get discouraged, keep trying every year." He also gave me hope by saying that he felt confident that my paintings would find acceptance. So I thanked him for his encouragement and kindness.

It is important to mention here that the Salon des Artist Français is held every spring in Paris

at the Grand Palais des Champs Elysees. It is an old Salon that goes back several centuries. Over 3,000 artists from around the world compete every year and there are awards; Gold, Silver, and honorary mention medals. It is also important to say that early last century the impressionist artists tried to display at the Salon but their art was refused.

In the spring of 1976, I took three of my best paintings and presented them to the members of the jury. To my great joy and surprise, all three paintings were accepted. It is during the first week of the salon that the members of the jury vote for the candidates and vote the awards. Besides the medals there are other awards like best landscape or still life, etc.

On the opening day, I found a seat not far from my three displayed paintings, nicely hung together. I was watching the visitors and their reactions to my work.

On the last week of the salon, I received a letter with the good news that I had been awarded the silver medal. Needless to say I was happy and proud. Every year after I submitted three new paintings. As I had received a silver medal, the three paintings were accepted and did not have to go through the jury. Each one of my new hanging paintings was labeled underneath with a plate giving my title "Silver Medalist." What a thrill. Praise the Lord.

In 1979, I not only received the Gold medal but also the "Paul Liot" prize for the best landscape of the 1979 salon.

My name, home address, and awards, plus a color photograph of each of the three displayed paintings appeared in the salon catalog. A few weeks later I had a visit from the Phillips Galleries interested in buying my work , followed by another gallery from London, England—Omell Galleries. Three months later they wanted to buy

more paintings. After one year I realized that I could make a comfortable living by nothing but my art. I quit NCR in 1980 and became the impressionist artist that I had always dreamt about and asked God to make me. All the Glory to Jesus who answered to my prayers.

C) The Generosity Of Jesus

God was very generous with me. I became a full time artist in 1980, which is exactly 31 years ago, and over 4,000 of my paintings are in prestigious homes in the USA as well as in Europe.

God never forgets our prayers. He knows better than we do the right time to grant them and He always grants to us more than what we ask for.

I have in my life many miracles. Some of them were related to car incidents when I was driving. I could have been killed several times. Every time that I am in imminent danger and call His name, I am miraculously saved.

D) A Trip To Remember

One of the most miraculous incidents I have experienced happened 24 years ago. I was travelling by car from Paris to Nice, which is about 650 miles. I was driving my car on the highway when on my control panel the large red STOP indicator came on. I pulled over. A heavy cloud of steam came out of the radiator when I opened the hood. I was lucky to stop at that spot, as first there was an emergency call box, and second, it was just before the road sloped up. I saw the telephone post near by. So I rang up the emergency personnel and explained what happened. They asked for the number of my car plate as well as my location and requested me to wait for a tow truck that would arrive within 30 minutes.

It was around 6 p.m. on the Friday of a three-day weekend. While I was thinking about the consequences of this incident, the tow truck

arrived. I explained what was wrong. He opened the radiator, which by then had cooled off. Obviously, it was empty. He filled it with water and asked me to follow him for a short distance on the highway. In less than a mile he pulled over, opened a large fence with a key and asked me to follow him for a couple more miles. The road was very narrow and surrounded by pine trees and hills. It was an abandoned area some 150 miles from Nice.

The tow truck stopped in front of a small workshop. No one was there and it was in the middle of nowhere. He said that I would have to leave my car till Tuesday and the mechanic could then check what is wrong with it and order the spare parts to fix it. That, he said, would take at least a week. Anxiously I asked him what I was going to do in the meanwhile. He explained that his mission had ended. His job was limited to clearing the highway of disabled automobiles for safety reasons. I asked him if there were any

hotels in the surroundings. "Twenty miles further on the highway," he said. I could have asked him to take me to the hotel with his tow truck but I didn't. I wanted a little time for reflection before making my decision.

We were speaking inside the little workshop when I noticed in a corner an empty gas container. I said to myself, "If I was able to drive the car from the highway to this place by filling the radiator with water, I can drive 20 miles if I take this gas container to fill the radiator with water from time to time till I arrive at the hotel." I told the security man about my plan. He hesitated and said that he could not do it. I asked him what was the reason. He said that, "If you take your car back to the highway and something happened to your car I will be responsible." "You are right" I said, "and I do not want you to be in trouble. I will sign a statement that will discharge you." He nodded. So I signed the paper, paid him for the container after he filled it with water, and paid the highway toll fee according to his request.

"One more question," I said, "how can I reach the highway?" "Take this road," he answered. The road was the opposite direction of the road we took to come from the highway. He said, "After approximately one mile you will reach a circle which has several roads. Look for the highway sign, it will point you to the highway."

I filled the radiator with water and started my new adventure by driving according to his directions. The STOP indicator was silent so far. After a mile, I was at the intersection but I did not see any sign for the highway. The area was deserted: no help, no directions, nothing. I picked one of the roads hoping it was the right one. After driving a hundred yards, the STOP indicator light came on. I stopped, checked the water in the radiator. It was still full; after all, I had driven only a mile. While wondering what I should do, I saw a car coming from the opposite direction. Finally somebody might be some help. When the driver saw me he increased his speed

and raced away. He was probably afraid to stop in that abandoned area.

It started getting dark. I could hear in the distance animal voices similar to the howl of a wolf. I really don't know. I started to feel some anxiety, so I prayed asking God for help. At that moment I heard an internal voice asking me to turn around and look in the opposite direction. I was relieved and amazed to see the highway sign, which was visible from that position. I thanked God for his help but I was wondering how was I going to take the road with my disabled car? Wait a second, I said to myself. When God helps it is a full help, I must have missed something. An idea came to my mind. Maybe God wanted me to stop the car because I was taking the wrong direction and His way of forcing me to stop the car was to use the STOP indicator by turning it on. "Yes," I said, "that must be it." The STOP indicator did not come on because of lack of water. As a matter of fact the radiator was full when I stopped.

It was obvious to me that God wanted to stop me before going further into the woods at night. My trust in God took me back to my driver's seat and I turned the motor on. Tears came to my eyes when I noticed that the STOP indicator stayed off.

I made a U-turn, found the highway, and praised Jesus who came to my rescue and saved me.

I kept driving on the highway. No red light yet. Twenty miles further I saw at the side of the road a hotel sign well indicated on the information panel and the highway exit was one mile further. The STOP light was still off. Should I stop or continue my way? I heard again that internal voice asking me to continue driving. So I did.

I had proceeded another 100 miles and I saw many hotel signs. I constantly checked the indicator light, which became for me like a

permanent communication link with God. As long as the STOP light was off it was a message from God to continue driving. I kept praising the Lord till I reached the city of Nice.

I took the direction to my condo. After crossing the heavy traffic of the city I finally reached the residence gate. I opened it with my remote. To reach my private garage, I had to drive in circles four levels up. I opened my garage door, drove my car inside, and the STOP sign came on. I couldn't believe it. Nothing is really impossible with God.

The second day, which was Saturday, I called the Citroen Garage for repairs. It was open. I refilled my radiator, which was probably totally empty, with the water that I brought in the gas container that I bought from that repair-shop-of-nowhere. I did not have any problems reaching the Citroen Garage. I explained in detail what happened to the mechanic. He asked me to leave the car.

After the long weekend the Citroen mechanic called me to say that one of the pistons was broken and he had to order the spare part. I could have the car back next Saturday he said.

When I went to get my car, the auto mechanic asked me to tell him again what happened. After listening carefully he said, "This is impossible. Driving a car 150 miles with a broken piston is not possible. I do not understand." I understood. It was a miracle from Jesus. I have kept that gas container so that I will always remember the great love that Jesus has for His people.

E) God's Presence In My Paintings.

Painting outdoors is a very strong communion between an artist and God, especially if the artist is a believer.

When I paint in the open air, I spend hours contemplating all the beauties that God created

and praise Him continuously. These uplifting feelings show on my canvas and are subsequently transmitted to its viewers.

When people visit my gallery and stand in front of my paintings, I can tell from their body language if they are strong believers. One day I observed a lady looking at one of my paintings for quite awhile, so I approached her, introduced myself, and saw that she had tears in her eyes. She told me about the strong uplifting emotion that she receives when looking at my artwork. My short conversation with her unveiled her deep belief in Jesus. She was a strong believer. This has not been my only experience.

During the 20 years my gallery has been opened, I have had many opportunities to analyze, study, and confirm that the interest my visitors show in my artwork varies according to their belief. The more they believe, the more they are able to perceive my praise and thanks that I

give to God while I am painting. I love to transmit God's peace to people's hearts. God has blessed me with a talent that allows me to do this. When I go out in the open air to paint I seek only those landscapes that inspire me with that peace. With God's help I capture that peace on my canvas that will then hopefully be transmitted to people's heart.

My biggest reward is when I receive from my collectors letters thanking me for bringing that peace into their homes. An amazing story happened in the home of one of my collectors. He was a very religious man. His house is full of my artwork. He was retired and spent most of his days taking care of his handicapped wife. He passed away a few years ago and is certainly in Heaven now. He spent much of his time in prayer.

One day he was sitting in a room praying. While doing so his eyes fell on one of my

paintings. It was the pond at Wequetonsing at the beginning of Beach Drive in Harbor Springs, Michigan. That painting has on the lower right side some bushes growing near the pond. While he was looking at that painting he discovered a scene from the Gospel of Matthew. Matthew 21:7: *They brought the donkey and the colt and placed their cloaks on them for Jesus to sit on.* The man was very excited when he spoke to me on the phone. I was even more excited myself. Normally I use a pallete knife and my strokes, which are expressed spontaneously on my canvas, are never premeditated. They come by the feeling that I receive from the light I see hitting the object. I express that light by mixing several colors and with my pallete knife my hand throws in various directions the paints on that particular spot on my canvas, mostly by impulses dictated to me through my five senses. This is what impressionism is about. So I asked him, "What do you see exactly." He said, " Jesus sitting on a donkey." "Can you take a picture of that

detail and send it to me," I asked. At that time, which was about 1982, the Internet did not exist. A few days later I received the photo by mail. As this man described, I saw Jesus sitting on a donkey and surrounded by bushes. I showed the picture to many people and they all confirmed what I saw. Glory to God who wants us to believe in Him in order that we will be saved.

F) God Has Already Helped Me To Spread His Word

I was one day with a group of people arguing about the existence of God. One of them asked me:

Q: Did God create everything?
A: Yes. I answered.

Q: He created then the good and the bad?
A: God creates only good. God does not create bad, or sin if you prefer.

Q: If so, from where did bad come?

The question was very important. So I gave him the answer that I thought would satisfy him. I tried to make it as simple as possible to understand.

A: God is light. His light fills the world with good. If an obstacle is in the way it generates behind it a dark area. This absence of light is referred to as bad.

Q: Yes, but God could have generated that obstacle. I am not convinced. I want proof that the source of sin is not from God.

I admitted that I did not have any answer ready to satisfy him. So I prayed for God's help and I felt the spirit of God dictating to me an answer that I was discovering myself the moment I pronounced it. Here is what I said:

A: We know from the bible the story of the fallen Archangel Lucifer. Before he fell with one third of the angels of light, heaven was sinless, and the light of God was filling His kingdom with nothing but good. The reason that God drove Lucifer and his followers out of heaven was because Lucifer committed the first sin ever. He envied God and wanted to be like Him. Let us for one moment think about what had happened. Lucifer envied God. Do you think that Lucifer inherited the sin of envy from God? If ever God did envy, He could not of course envy His creature. The only possibility left is to envy Himself, which does not make sense. Therefore, sin came from Satan and not from God.

He nodded and was convinced that God is not the creator of sin. Sin was created by Lucifer, which was started by envy, followed by hate, jealousy, destruction, etc.

I have another amazing story to tell which happened to me a few months ago.

I was in my house wearing my painting clothes, ready to go to my studio to continue painting "The Life of Our Lord." My studio is not in the house but above the garage. I was about to leave when, I do not know why, I felt the desire to sit at the piano and play. I normally do this to relax. A few minutes later, I heard someone knocking on my door. I opened it and found a young man in his thirties standing there with two children, who looked to be 10 and 14. He had in his hand a bible. It was not difficult to ascertain from which denomination he was from. I had already received visits from other people of the same denomination. The bible that they carry is a Christian bible which has been modified. Some words are altered which can change the real meaning of the verse. Consider for example John 1:1, The Christian bible says: *In the beginning was the word, and the word was with God, and the word was God.* If you open their bible to the same verse of John

you will notice that the one-letter word *a* has been added and the verse ends like this *...and the word was a God.* This single added letter totally changes the meaning which is misleading and unfortunate for those people who listen to them. I asked if he was from the denomination that I thought he was from and he nodded. I told him that he had knocked on the wrong door. He did not understand what I meant so I continued by telling him that I deeply believe that Jesus Christ is my God and our Savior and that He is the creator of the universe and all it contains. I told him that he is welcomed if he believes the same and the conversation started and continued in front of the door for some 15 minutes. He was asking questions, showing his interest in what I was saying. His daughter of 14 was also very interested. The Holy Spirit inspired me and I succeeded by convincing him and his daughter. To make the story short, he left me almost converted to Christianity and said, "Please pray for me." I promised to pray for him and his family. To me this is God's will to send him just before I left the house. In my daily prayer I include

him and his family when I pray for the lost sheep
without their shepherd.

Chapter 2

A Relationship With Jesus Christ

We can never dream of having a better friend than Jesus. He can guide us, save us from danger or accidents, heal our sicknesses, listen to our problems and help us to solve them, advise us, and most importantly, love us.

What does he need in exchange? For us to love Him, trust Him, and believe in Him. He wants us to love each other. This means not to hate anyone or hurt anyone by our thoughts or deeds.

We have to believe that Jesus Christ is our God and Savior. In Section II of this book I write about what God inspired me to explain about the Holy Trinity. A good understanding of this section will help us to believe in Him as our God. Chapter 4 of this book, "The Life of Our Lord Paintings", that I was inspired to paint and represent, will help one to

know Him and love Him. And finally in Chapter 1 "My Relationship with Jesus" I explained how we can enjoy and strengthen our relationship with Him. We know how much He loves us and what He did to save us from eternal death. He took on Himself all our sins and washed away our iniquities with His own blood that He shed on the cross when He sacrificed Himself as the Lamb of God. Can we imagine any friend who does such a sacrifice for us other than Jesus?

We must remember that we are children of God. He is our Father. A relationship between a child and their father is very possible. It is even a certitude if the father encourages it. Is Jesus encouraging us? Yes. In Matthew 7:7 we can read:

7Ask and it will be given to you; seek and you will find; knock and the door will be opened to you.

What better invitation and encouragement can we have? We might, however, still hesitate because

we are sinners and we are afraid or ashamed to accept His invitation. God also thought about that, and in order to make it easy for us, He gave us the parable of the prodigal son Luke 15:21-24:

[21]The son said to him, 'Father, I have sinned against heaven and against you. I am no longer worthy to be called your son.'

[22]But the father said to his servants, 'Quick! Bring the best robe and put it on him. Put a ring on his finger and sandals on his feet.

[23]Bring the fattened calf and kill it. Let's have a feast and celebrate.

[24]For this son of mine was dead and is alive again; he was lost and is found.' So they began to celebrate.

The above parable is also valid today and tells us that this is exactly what happens systematically in heaven. If we pray to Jesus, confess our sins, and

ask for forgiveness after promising Him a complete and sincere repentance, Jesus will forgive us. It is only after the above prayer and repentance can we establish a continuous relationship with Jesus.

It is much easier to have a relationship with God than with any human being because God is OMNISCIENT. He perceives and knows everything in our mind or heart. We do not have to explain. He understands perfectly what we want, but we have to invite Him to share our thoughts or our feelings, otherwise He will not intrude because He respects that freewill that He granted us.

We must not worry about bothering Him by saying "He is too busy to interrupt Him with my personal problems." No. God is OMNIPRESENT. He can be simultaneously with each one of us. He is impatient to hear from us. Remember what He told us in Matthew 7:7: *⁷Ask and it will be given to you; seek and you will find; knock and the door will be opened to you."*

No matter how complex our problems He is OMNIPOTENT. He has unlimited power. He is able to do absolutely anything He chooses to do which is in accord with His own nature.

From what was said, we realize that having a relationship with Jesus should not be difficult. But what is next?

The answer is very simple. We have to act exactly the same way we act when we love someone.

What exactly happens when we love someone?

A) we think always about him or her
B) we declare our love
C) we prove our love

By using the same thinking, here is what we have to do for Jesus.

A) Always Think About Jesus

This is very simple. He is the creator of the universe. We are His creatures and whatever we see is a reminder for us of who He is and how beautifully he conceived everything. As a plein air artist for over 50 years I have had the privilege to contemplate and admire what He created. Therefore, He is permanently occupying my mind. I see Him and feel Him everyday.

We are not all artists with this opportunity of seeing Him and remembering Him all the time. Nevertheless, we have many opportunities to be out of doors for a walk, or a picnic. We have been on vacations. We have certainly admired the views, but we did not try to think who is the cause of all this beauty.

From now on, we have to remember that God, our creator, is behind all that. He is the source. He is the cause. By doing so, we will always remember

Him and this will be a good way to keep Him in our mind.

There are many other things which will remind us of Him. All the beautiful music and beautiful voices that uplift our soul, their source is God. He is the one who inspired the musician, he is the one who has gifted the singer with a beautiful voice. We are not speaking here about the type of music that excites our sensuality or our physical senses. We are speaking here about what uplifts our soul to God.

We are surrounded by amazing inventions that we use everyday like the Internet, TV, airplanes, computers; among thousands of other things which have become so familiar to us that we never had the chance to analyze their source of existence. We might think from time to time about the name of the inventor. But who gave to that inventor the inspiration but our Creator? Some might be skeptical about the fact that God

is behind all that. If we analyze when and why everything was invented we realize that without any doubt the Almighty inspired the scientists, physicians, or other inventors to invent what His people need at the time they need it. This is what Jesus said in John 15:5: *5I am the vine; you are the branches. If you remain in me and I in you, you will bear much fruit; apart from me you can do nothing."*

If we are attentive to what we see, and remember that God is behind every good invention, we will always remember Him.

This is also true for all God's creations, which remind us of Him.

- The infinitely big galaxies
- The infinitely small cell in the human brain
- The concept of a human body
- Nature and the behavior of all living creatures

We can go on and on and realize that opportunities to remind us of God are almost unlimited. What is missing in us is to think more often, if not always, about our Lord Jesus Christ, who is the source of everything. He is the Word of God and through Him everything was created.

Psalm 86:12: *[12] I will praise you, Lord my God, with all my heart; I will glorify your name forever.*

B) Praise Him (Declare our Love to Him)

As explained above, everything around us helps us to remember Him. This might be enough to convince our mind but not to convince our soul.

Whenever, we see something that reminds us of Him, we have to praise Him. By doing this, our faith in Him will grow, and so too our love for Him. When our love becomes part of our being, our soul will unite us with Jesus as explained in the Book of John.

John 15:9,11: *⁹As the Father has loved me, so have I loved you. Now remain in my love. ¹¹I have told you this so that my joy may be in you and that your joy may be complete.*

The more our faith grows, the more we will feel and understand the scriptures of the bible. Therefore, we have to read the bible, contemplate what we have read, and try to live each scene of it as if we were present at that moment.

Our growing faith will bring life to what we do. When I paint outdoors and praise Jesus for His beautiful creations, my praise shows in my work. People who have seen or are in possession of my artwork write me letters to tell me about a very strong spiritual feeling they perceive when spending time in front of my paintings. They describe that feeling with expressions like uplifting or inspiring. I noticed that those who are the most sensitive to perceive that feeling are those who are believers in Jesus Christ.

There are many things happening to us or around us everyday that we do not notice or even consider although they are living miracles. How many times we couldn't do what we wanted because some obstacles presented themselves? We get upset and are forced to change direction. Then we discover something much better than what we wanted originally. When this happens we should give thanks and praise to our Lord who knows what is the best for us. Those signs which happen and are unseen by us, when noticed become very important to increase our belief and grow our faith.

C) Prove That We Love Him

The best proof to Jesus that we love Him, is to do what He asks of us.

If we already love Him, believe and trust in Him. If we are obeying His commandment and we love our neighbor like ourselves, we have proven already to Jesus that we love Him.

But what does love our neighbor really mean? If we understand from this that we have to love those we know like parents, family, and friends, it won't be enough.

Jesus wants us to help those who are in need. This is not limited to financial help. It goes beyond that. What Jesus is asking is a spiritual help which can only be given by praying.

He wants us to intercede for those who are suffering in this world and also for the souls of those who died and need our prayers. This complicated subject of interceding needs some clarifications.

C1) Intercede For People Who Suffer

We hear every day in the news about wars, natural disasters, famine, accidents, sickness, etc. This is not God's work. He is our Father. He has proven His love for us by

accepting to shed his blood on the cross and die for our salvation. So who is responsible for these calamities?

Amazingly, the answer is us. When we disobey God's commandments we automatically are sinners. Sin being from Satan, we are then obeying Satan, which also means we are choosing the Devil as our master.

In Luke 16:13:

¹³No one can serve two masters...

In Matthew 12:30:

³⁰Whoever is not with me is against me, and whoever does not gather with me scatters.

By choosing the Devil as a master, we are, in a way, allowing him to do his will.

What is Satan's will? Satan and his followers were driven out of heaven because they committed sin. Since then Satan desires to hurt God. But knowing that no one can hurt God, he is hurting those that God loves, meaning the human race. By hurting us, Satan is in a win-win situation. On the one hand he is indirectly hurting God and on the other hand he is making us believe that all the suffering is a punishment from God for all the sins we committed. Unfortunately some people believe this and go away from God.

Why doesn't God stop Satan instead of asking us to intercede?

God knows that Satan has no power over us unless we submit to his will by committing sins. God gave us freewill. If we choose to disobey Him, He cannot force us to obey Him, otherwise He will be contradicting

Himself. So what can He do? Only one alternative is left. Either God will leave things as they are and make people pay for their mistakes, or He will ask us to intercede for them in our prayers.

Interceding for others is very powerful. God accepts and hears those who pray for the good of others, because He has asked us to love our neighbors. We have to understand that God is love, which is the opposite of hate, and whenever our prayers express love He listens.

Satan is much smarter and stronger than we are. Remember, he was originally an archangel and had received a lot of power from God. After he was driven out from heaven he became an angel of darkness. However, he still possesses his power which he is using against us in this world for destruction. He is also very smart, he knows

our weaknesses and tempts us precisely where we are vulnerable. If, for example, we need money he tempts us to steal. If we are afraid to be punished he tempts us to lie and so on for whatever can push us to sin.

Whenever we are tempted to do something wrong and before we act, we have to remember that it is the devil who is tempting us and God is watching. This is very important for our salvation. If we feel weak to rebuke the temptation and we cannot drive out the devil, we have to use the authority that God gave us and say with conviction to the devil, "In the name of Jesus I command you devil to go away." The moment you pronounce the name of our Lord Jesus the devil will disappear.

C2) Intercede For The Dead

If we believe in eternal life, we must also believe that in addition to our physical

body, which will die, there must be within us something else which will survive. Read what the bible says on that subject 1 Thessalonians 5:23:

²³ May God himself, the God of peace, sanctify you through and through. May your whole spirit, soul and body be kept blameless at the coming of our Lord Jesus Christ.

So there are three parts: body, spirit, and soul. In order to understand this very complex subject let's start from the beginning and see what God said about our origins Genesis 2:7:

⁷Then the LORD God formed a man from the dust of the ground and breathed into his nostrils the breath of life, and the man became a living being.

So originally we are dust, but have in us the breath of God. The dust is from this

natural world but the breath of God is from a different world which is a spiritual world because God is a spirit.

What is from this natural world is perishable, therefore that part of us which is our physical body, is also perishable and will go back to dust.

The other part, which is the breath of God, is from God. And what is from God is eternal. Therefore the two remaining parts "spirit" and "soul" are eternal.

When we are alive and living in this world the spirit and the soul are within us. They are invisible to us. Spirits, both good and bad, surround us in this world, but we cannot see them, hear them, or feel them because our five senses are natural and not spiritual. Our spirit has a spiritual body which, as soon as our physical body dies, is released and

will go to live in the spiritual world where it belongs.

Our soul is the intimate part of our self. Some refer to it as our mind or our self. Here in this explanation we will refer to it as the bible does, "our soul." Each soul receives during its conception a gift from God which is the freewill. Free will means that the soul has the choice to be obedient to God or disobedient to God.

In spite of the fact that we have a brain to think with and a heart to feel with, it is our soul that decides and chooses between what is good and what is bad. When necessary, the soul can give instructions to the brain and order it to execute a physical act that could be good or bad. Good like help someone or bad like kill someone. If the decision of the soul does not necessitate any physical act, but is rather an act of the mind, like praying, or

blessing or cursing someone, it is our spirit which will act spiritually, not our brain.

As the soul has received from God the gift of freewill, the spirit has also received a gift, which is the seed of faith.

The seed of faith, like any natural seed, in order to grow needs to be nourished. Any good deeds implemented by our soul will nourish the seed of faith. Good deeds decided by our soul could be executed either by our physical body, if the deed requires a physical act, like saving someone from drowning, or by our spirit if the deed does not require a physical act, like praying. When the seed of faith receives continually from our soul good deeds it grows faster and faster till our spirit is born again by the Holy Spirit.

Hereafter are some scriptures from the Gospels confirming the above explanations.

1 Peter 1:23: *²³ For you have been born again, not of perishable seed, but of imperishable, through the living and enduring word of God.*

John 3:3: *³ Jesus replied, "Very truly I tell you, no one can see the kingdom of God unless they are born again."*

The contrary is also true. If our soul decides to choose bad deeds continually, the seed of faith won't grow and the spirit will die.

Here are two verses confirming this last paragraph. Matthew 8:21-22: *²¹ Another disciple said to him, "Lord, first let me go and bury my father." ²²But Jesus told him, "Follow me, and let the dead bury their own dead."*

Explanation: It is the spirit of those who have to bury the dead that were dead and not their bodies.

We already briefly explained the spiritual body. We understood that when the physical body dies, the spiritual body together with the soul will go to the spiritual world.

As we live in this world with our physical body, our spiritual body will live for eternity in the spiritual world either with God or away from Him.

Those who have been born again, as previously explained, will be with God.

Being with God is referred to in the bible as ETERNAL LIFE in a place called Heaven or the Kingdom of God. Our spiritual body will look like us when we were living in this world. The good news is that it will not carry our sickness or any mutilations. It will be perfect and ageless.

And those whose spiritual body is dead

will be away from God in a place called Hell, which the bible describes as ETERNAL DEATH.

As we explained previously the spirit is eternal, it will never die. What the bible means by eternal death is the fact that those spirits who are away from God will be in the darkness, deprived of the Sun of Heaven which propagates love through its warmness, and wisdom through its light.

In other words, they will be in a place where they will have the opposite of love, which is hate, and the opposite of wisdom, which is madness. What kind of life will it be where every spirit will hate, beat, or fight every other spirit, and mad spirits will be surrounded by mad spirits? The worst of it is that their life will be like this for eternity because their last chance for repentance was on this earth before they died.

For those of us who are still alive, we had better prepare our eternal life while we are on this earth. We can prepare it simply by following and respecting God's commandments. Let us repent and ask for forgiveness whenever we do something wrong. God accepts our repentance and will forgive us only during our life on this earth.

What is really absurd is the time we normally spend preparing our vacations; spending time studying the weather, the cost, the currency, or language of our destination, and all this for a trip of a couple of weeks. What about that final trip which is for eternity? The best way to prepare our eternal life is to start today our relationship with Jesus. He will help us and guide us because no one knows what can happen tomorrow.

Now why does Jesus want us to intercede for the dead? It is certainly not for those

who are in hell. And those who are already in heaven do not need our prayers. It is for those who do not deserve to go to hell and are not ready or properly prepared to be in heaven. This is the case of the majority of humanity. Many people have never heard about Jesus, or believe in God but not Jesus, or believe in a God who is not the true God. You have also those who do not believe in anything, or those who believe in some power or energy somewhere. Some people believe only in what they see and is useful to them, like the sun, the moon, or mother nature. We can go on and on enumerating all kinds of beliefs.

No matter what people believe, what counts to God is how they behaved during their lifetime. Were they kind and loving people or a mean and hateful living being? When God created mankind with freewill, each soul acted according to its own decision.

In the world of the spirits there are three places. Each is separated from the other. Spirits cannot go from one place to another without God's permission.

We already know about heaven where God is with His angels and all born again spirits. We also know about hell which is the destination of all bad spirits including Satan and his followers, the fallen angels who became angels of darkness or demons.

The third place in the world of the spirits is called purgatory. It is a place where the souls will receive a complete purification before entering Heaven and will also acquire a full knowledge about God.

This purification is the same type of purification that we have already experienced during our life in this world. Each one of us might remember a moment of repentance

after realizing how bad an act that had been committed was. This feeling of repentance might have made us cry and sob bitterly. This is the suffering of the soul which has nothing to do with the suffering of the body. This suffering that we have endured could be a prelude to what our soul will feel when it receives a final purification in purgatory. The intensity of the suffering and the duration that each soul will spend in purgatory depends on the state of the soul when we died on earth.

While those souls are purified in purgatory, angels or other good spirits in heaven will receive permission from God to go to purgatory to teach about who Jesus Christ is and what heaven is. These explanations and teachings will enlighten those souls during their purification for as long as required till they are totally purified and aware of the endless love and justice of God.

Yes, interceding for the dead is important for them. If we love those who have passed away, like parents, relatives, and friends, we are asking God to lighten their suffering and shorten its duration.

It will be thoughtful if we also pray for those spirits who are in purgatory but have nobody to pray for them. God will bless us for such a good deed.

God is merciful and will always listen to those who love Him and pray for the good of others.

Chapter 3

The Story of the Paintings

When you pray to God with faith and ask Him to help as you do a good deed, not only does He answer your prayers, but He will surprise you with much more than you were expecting.

In my daily prayers I ask God to give me opportunities to meet people who have lost their faith. What these people need is to meet a believer who they can trust and who has the ability to dissipate their doubt and restore their faith. On various occasions I have met friends and other people who, during a friendly conversation, spoke about the doubt they have. Sometimes, I have an answer that allows me to dissipate their doubt and bring back to them the faith that they lost. Other times my answer is not convincing or I feel incompetent to answer. Amazingly, I feel help coming to me from the Holy Spirit and I discover the answer coming out of my

mouth.

This chapter explains how God answered generously my prayer in a different and unexpected, but better way. Here is the story.

In January 2011, I went with my wife to spend some vacation days in a place away from the bitter cold of Michigan. Normally I take the bible with me to read and a sketchbook to draw what I see. After a few sketches I was not feeling inspired so I put aside my sketchbook and opened my bible. The first page I opened to was at the beginning of Jesus' ministry when He met His first four disciples (see Matthew 4:48-22). While reading I saw in my spiritual eyes the whole landscape of the Sea of Galilee with hills in the background. I saw the sky with its clouds and some seagulls flying. In the foreground of the paintings I saw Zebedee in his boat with his two children, John and James, cleaning their nets. I saw Jesus talking and inviting them to follow Him under the surprised look of their father. Behind Jesus I saw

Peter and Andrew following Him after they left their boat behind them. This landscape was very clear in my mind as if I was present that day at that moment watching the scene.

The vision was so real, I attempted to sketch it. I opened my sketchbook and in a short time I was able to reproduce on a page the whole thing. I was amazed to discover how easy it was. It is important to note here that I have never tried to draw or paint a subject from my imagination. As an impressionist artist, I have always painted what I see.

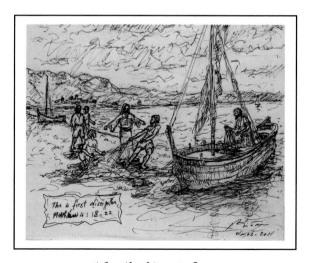

I was encouraged and I spent the rest of my vacation reading and sketching from the bible.

When I went back home I ordered ten large size canvases; six rectangular (80" x 60") and four square (65" x 65"). Above my garage I had built a large studio 9 years ago, and always wondered why I built it as I normally paint outdoors. It is only when I started painting "The Life of Our Lord" on large size canvases that I understood that it was God's design.

I took my sketchbook and started to reproduce on the large canvases the small sketches. The enlargement required more detail, which was not difficult except for the portraits. Each portrait required additional studies. The age of the person, the expression of his or her face should correspond to the

story of that particular moment of the subject.

One of the biggest problems was painting a full story and showing it on one canvas. As if someone asks you to see a movie and to summarize it in one picture. The landscapes or the surrounding of the subject also needed study and research.

When the drawing was done, a series of other problems presented themselves during the coloring. What time of the day was it? What is the source of the light? Is it daylight or candlelight? Where should the shadow of each lit subject be and how long should it be? What about reflections? What about the case of several sources of light, etc.

All these difficulties do not exist if you are painting a real subject with real people. Add to that the shape of each person's clothes, the folds, which have to follow the movement, what should the color be of the area directly exposed to the light or in the shade, and so on.

All these problems were new to me, because I was used to painting what I see, not what I imagine. Like the size of people sitting or standing close or far away. What about sloping surfaces and the size of the people or animals climbing or descending, etc?

My sixty years of experience and my strong knowledge of perspective rules and colors that I have been teaching in my art seminars certainly helped. But I admit that without God's help who was guiding me I probably would have failed in this project.

I was in communion with God, keeping Him updated with these serious problems that I was encountering. His answers were by different means, sometimes immediately and sometimes early in the morning, waking me at 5 a.m. with the solution. Most of the time He gave me some hint without giving me the full solution as if He wanted me to find it myself. It was a wonderful experience and I was enjoying painting without any particular plan. I thought that I would display each finished painting in

my galley when a voice in my head woke me up early one morning telling me that I have to stop painting randomly like this. I must paint "The Life of Our Lord." The new message was very important. First it made me realize that this is a mission from God. Second it allowed me to organize myself and with God's guidance I came to the following conclusions:

- I would have to transform the lower level of my gallery to a museum where all these paintings will be permanently displayed graciously to the public.

- The paintings should not be sold. However, churches, museums, and interested people can order a giclee copy in the size they desire.

- In the long term, the paintings will be donated to major internationally known museum with the condition that they must be permanently displayed all together in a large room.

- I must write a book showing and explaining the paintings as well as telling the complete story.

From a practical point of view, now that I knew where to hang the paintings, I measured the total surface of my 1st level gallery walls and I determined that the total of those large paintings could not exceed 14 paintings.

So I bought an additional 10 canvases. I decided to divide the Life of Jesus Christ into four sections, and I selected for each section the appropriate subjects from the Bible. The titles of the 14 paintings within the four sections are:

#	Painting Title	Section
1	The Annunciation	His Birth
2	The Birth	" "
3	The Flight in Egypt	His Childhood
4	At The Temple With Doctors	" "
5	The First Four Disciples	His Ministry
6	The Marriage in Cana	" "
7	Jesus Resurrects a Widow's Son	" "
8	Feeding 5000 People	" "
9	The Last Supper	His Last Days
10	The Betrayal By Judas	" " "
11	The Humiliation of Jesus	" " "

#	Painting Title	Section
12	The Crucifixion and Death of Jesus	" " "
13	The Resurrection of Jesus	" " "
14	The Ascension	" " "

It was in early May 2011 when I received this last message. At that time I had already finished four of the paintings. In reality only three paintings related to "The Life of Our Lord." The fourth painting was an interesting subject from the book of Revelation that I selected before knowing about my mission. The other three paintings were number 5, 11, and 7. So I started focusing on the 11 remaining paintings.

It was Friday August 19, 2011 and I was painting "Feeding 5000 People." All that time that I was painting, one by one, the bread, I was praising the Lord for His love to His people. When I went to bed that night, after midnight, I could not take away from my mind how Jesus fulfilled that miracle and how five small loaves of bread and two small fish were now multiplied by thousands to feed 5,000 families. It was 3:15 a.m when God woke me up with

a new message.

It was a very clear message. Here is what it said: "I listened to your prayers by giving you the possibility to spread the word with your art. You have responded to my call and have already started to paint the life of Jesus Christ. Your paintings will assist many people who also are praying to spread the word without any effort or cost to a multitude of other people. This multiplication will allow millions and millions of people to receive the message with the speed of electricity.

The multiplication of the bread I was praising the Lord for is now repeated by multiplying the message of spreading the word. When I asked God how do I proceed, His answer was clearly articulated and presented in sequential logical instructions. "Here is what you have to do. Write it down." So I stepped out of my bed and went to my desk to write. It was 5 a.m. Here is what the message says:

Spreading The Word

If you believe in Jesus Christ and you pray to God to use you to spread His word, you can do it now in a few seconds and allow thousands of people to instantaneously receive and spread His Word.

Just follow these simple and easy instructions which will not take more than a few seconds.

1. Go to www.pierrebittar.com/biblicalpaintings. html and visit "The Life of Our Lord" from the Annunciation to Ascension painted by an impressionist artist who was commissioned in 2011 by God to spread his word through his paintings.

You can also use your mobile phone (smart phone) by scanning the QR code illustrated below.

2. Email the received web page to your family and friends who are also willing to spread the Word of God and ask them to do the same thing.

3. If you belong to a Christian school, Church, Bible study group, etc, ask permission to display this flyer on their information board so other believers can also spread the Word of God.

God Bless You

This flyer is on my website and can be printed out.

I continued with the rest of the 14 paintings which are now on my website. In addition to the paintings you can also view on my website a video interview. I was in my studio commenting on and explaining this mission.

You will also find an animated radio interview of 50 minutes explaining the difficulties I encountered while painting them and how God was guiding and helping me.

To conclude this chapter I want to thank Jesus for answering my prayer by allowing me to spread His word through a variety of means, including my art.

This was the biggest and the sweetest surprise I have ever had.

Chapter 4

"The Life of Our Lord" Paintings

This chapter contains the 14 paintings of "The Life of Our Lord." They are classified in sequence according to those events in the Life of Jesus Christ on Earth. "The Life of Our Lord" paintings are divided in four periods.

His Birth: Paintings 1 and 2
His Childhood: Paintings 3 and 4
His ministry: Paintings 5, 6, 7, and 8
His Last Days: Paintings 9, 10, 11, 12, 13, and 14

Each painting is preceded or followed by
1. Prophesies from the Old Testament

2. The New Testament verses which were the source of the inspiration in realizing the painting.

3. Some inspired notations.

Painting No. 1

The Annunciation Of Jesus

It was 2,700 years ago, and 700 years before the birth of Christ, that God announced to his people in the Old Testament of the Bible through the Prophet Isaiah, His coming on Earth in Jesus Christ.'

Isaiah 7:14:

Therefore the Lord himself will give you a sign: The virgin will conceive and give birth to a son, and will call him Immanuel.

*Immanuel means "God is with us."

Luke 1: 26-38

26 *In the sixth month of Elizabeth's pregnancy, God sent the angel Gabriel to Nazareth, a town in Galilee,*

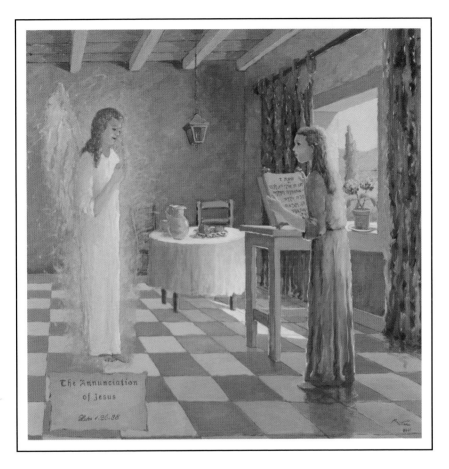

27 *to a virgin pledged to be married to a man named Joseph, a descendant of David. The virgin's name was Mary.*

28 *The angel went to her and said, "Greetings, you*

who are highly favored! The Lord is with you.

29　*Mary was greatly troubled at his words and wondered what kind of greeting this might be.*

30　*But the angel said to her, "Do not be afraid, Mary; you have found favor with God.*

31　*You will conceive and give birth to a son, and you are to call him Jesus.*

32　*He will be great and will be called the Son of the Most High. The Lord God will give him the throne of his father David,*

33　*and he will reign over Jacob's descendants forever; his kingdom will never end."*

34　*"How will this be," Mary asked the angel, "since I am a virgin?"*

35　*The angel answered, "The Holy Spirit will*

come on you, and the power of the Most High will overshadow you. So the holy one to be born will be called the Son of God

36 Even Elizabeth your relative is going to have a child in her old age, and she who was said to be unable to conceive is in her sixth month.

37 For no word from God will ever fail."

38 "I am the Lord's servant," Mary answered. "May your word to me be fulfilled." Then the angel left her.

Painting No. 2

The Birth of Jesus

The Greatest Event that Has Ever Happened

What could have been a better event than when our Creator, the Creator of the Universe, came and dwelled with us on the Earth? This happened in Bethlehem, a small town in Israel 2,000 years ago. Here is what God had announced to us through his prophets hundreds of years before he came on earth.

Isaiah 9:6:

For to us a child is born, to us a son is given, and the government will be on his shoulders. And he will be called Wonderful Counselor, Mighty God, Everlasting Father, Prince of Peace.

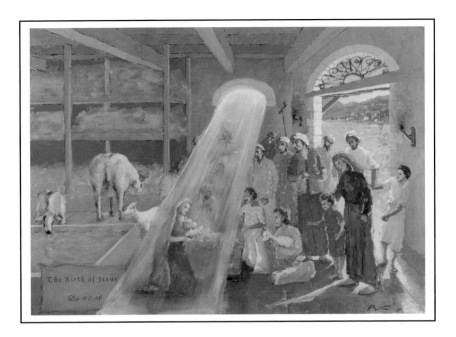

Micah 5:2:

"But you, Bethlehem Ephrathah, though you are small among the clans of Judah, out of you will come for me one who will be ruler over Israel, whose origins are from of old, from ancient times."

*The distant past = for ever = Eternity

7 *and she gave birth to her firstborn, a son. She wrapped him in cloths and placed him in a manger, because there was no guest room available for them.*

8 *And there were shepherds living out in the fields nearby, keeping watch over their flocks at night.*

9 *An angel of the Lord appeared to them, and the glory of the Lord shone around them, and they were terrified.*

10 *But the angel said to them, "Do not be afraid. I bring you good news that will cause great joy for all the people.*

11 *Today in the town of David a Savior has been born to you; he is the Messiah, the Lord.*

12 *This will be a sign to you: You will find a baby wrapped in cloths and lying in a manger."*

13 Suddenly a great company of the heavenly host appeared with the angel, praising God and saying,

14 "Glory to God in the highest heaven, and on earth peace to those on whom his favor rests."

15 When the angels had left them and gone into heaven, the shepherds said to one another, "Let's go to Bethlehem and see this thing that has happened, which the Lord has told us about."

16 So they hurried off and found Mary and Joseph, and the baby, who was lying in the manger.

Helpful Explanations

The following explanations will help those who are not familiar with the Bible Scriptures and are willing to read and understand in order to believe.

God: There is a Holy Trinity, which is Father, Son, and Holy Spirit in the one and only God; a triune God. To learn more see Section II of this book.

When we refer to any one of the three we are referring to one God. God existed from eternity. He is out of the realm of time and space. Therefore he is uncreated and eternal. God is our Creator and the Creator of the Universe. God considers His creation of Man as His masterpiece. Therefore, He came on Earth to save us from eternal death because His love for us has no limit. He created each one of us in three parts: body, soul, and spirit. The body allows us to live in this world. That is why we are visible to each other. When the body has finished its mission, it dies. Then the Spirit is released from the body and will live for eternity, either with God or away from Him. Being with God is referred to as eternal life, and living away from Him is referred to as eternal death. When we read in the Bible that the Son of God came to save us from eternal death, the Bible is referring to our spirit and not to our physical bodies.

The soul, which is different from the body and the spirit, is our intimate person which decides to do good or bad, according to the free-will which was given to us from God the day we were conceived, and will follow our spirit when we pass away. See more in Chapter 2 - C2.

The Word of God: The Word of God is the source of all Creation. When we read in Genesis, which is the first book of the Bible, we will notice that all creation happened according to his Word. "Let it be," He spoke, and it was. Read more in Section II.

After this simple and quick explanation, let us go to some verses of the Bible in regard to the birth of Jesus Christ.

John 1:1-5: *¹In the beginning was the Word, and the Word was with God, and the Word was God. ²He was with God in the beginning. ³Through him all things were made; without him nothing was made that has been made. ⁴In him was life, and that life*

was the light of all mankind. [5]The light shines in the darkness, and the darkness has not overcome it.

John 1:14: *The Word became flesh and made his dwelling among us. We have seen his glory, the glory of the one and only Son, who came from the Father, full of grace and truth.*

1 John 5:11-13: *And this is the testimony: God has given us eternal life, and this life is in his Son. Whoever has the Son has life; whoever does not have the Son of God does not have life. I write these things to you who believe in the name of the Son of God so that you may know that you have eternal life.*

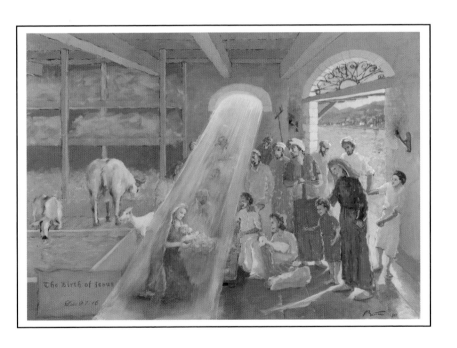

The Birth of Jesus

Painting No. 3

Flight Into Egypt

Some time after the birth of Jesus, King Herod heard about the birth of the Messiah, who the Jews had been awaiting for several centuries.

He should have been honored and proud that this historic and divine event which had been announced hundreds of years before and had been expected by most of the people of Israel happened during his reign.

Instead, he was troubled and worried about losing his throne. He gave orders to kill all boys in Bethlehem and its vicinity who were 2 years old or younger, the age calculated by the information given to him. The complete story is told in Matthew 2:1-23.

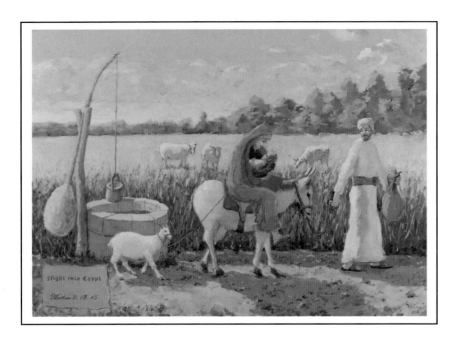

Matthew 2:13-14

13 When they had gone, an angel of the Lord appeared to Joseph in a dream. "Get up," he said, "take the child and his mother and escape to Egypt. Stay there until I tell you, for Herod is going to search for the child to kill him."

14 So he got up, took the child and his mother during the night and left for Egypt,

Painting No. 4

Childhood of Jesus (12)
At the Temple with Doctors

Luke 2: 41-52

41 *Every year Jesus' parents went to Jerusalem for the Festival of the Passover.*

42 *When he was twelve years old, they went up to the festival, according to the custom.*

43 *After the festival was over, while his parents were returning home, the boy Jesus stayed behind in Jerusalem, but they were unaware of it.*

44 *Thinking he was in their company, they traveled on for a day. Then they began looking for him among their relatives and friends.*

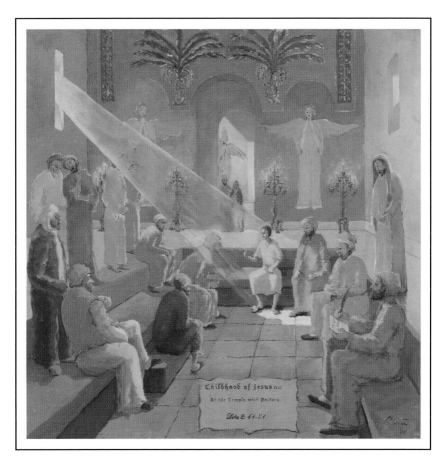

45 When they did not find him, they went back to
Jerusalem to look for him.

46 After three days they found him in the temple
courts, sitting among the teachers, listening to them

and asking them questions.

47 Everyone who heard him was amazed at his understanding and his answers.

48 When his parents saw him, they were astonished. His mother said to him, "Son, why have you treated us like this? Your father and I have been anxiously searching for you."

49 "Why were you searching for me?" he asked. "Didn't you know I had to be in my Father's house?

50 But they did not understand what he was saying to them.

51 Then he went down to Nazareth with them and was obedient to them. But his mother treasured all these things in her heart.

52 And Jesus grew in wisdom and stature, and in favor with God and man.

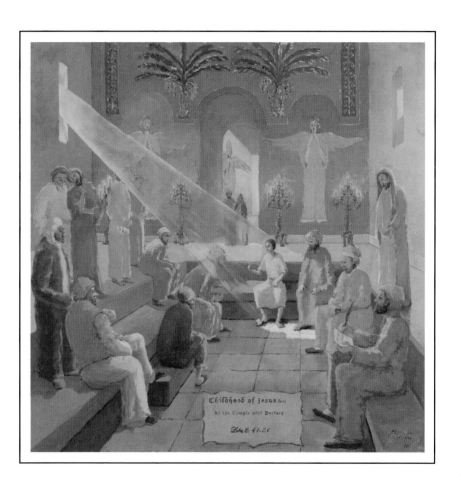

Childhood of Jesus (v)
At the Temple with Doctors
Luke 2: 41-51

Painting No. 5

The First Four Disciples

Jesus was estimated to be 30 years old when His ministry started. After having been baptized by John the Baptist (see Matthew 3:13-16) He was led by the spirit into the wilderness to be tempted by the devil. After fasting 40 days and 40 nights, the devil tried several times to tempt Him, but he failed, gave up, and left Him (see Matthew 4:1-11). When Jesus heard that John the Baptist had been put in prison, he began to both preach and seek disciples.

Matthew 4:18-22

18 As Jesus was walking beside the Sea of Galilee he saw two brothers, Simon called Peter and his brother Andrew. They were casting a net into the lake, for they were fishermen.

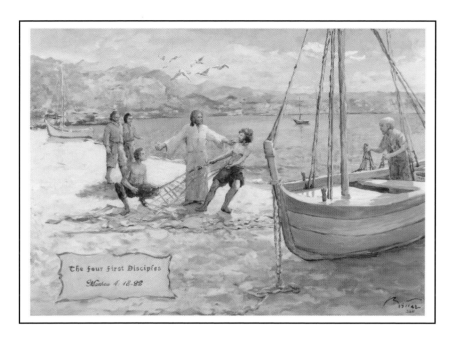

The Four First Disciples
Matthew 4. 18-22

19 "Come, follow me," Jesus said, "and I will send you out to fish for people."

20 At once they left their nets and followed him.

21 Going on from there, he saw two other brothers, James son of Zebedee and his brother John. They were in a boat with their father Zebedee, preparing their nets. Jesus called them,

22 *and immediately they left the boat and their father and followed him.*

*fish for people.

Because fish are hungry and are attracted by food, fisherman are able to catch them. Likewise, men are hungry for the truth and will come to Jesus' disciples to have that truth which is in Jesus (see John 18:37).

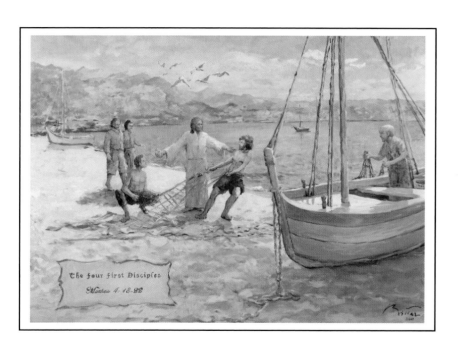

The four first Disciples

Matthew 4, 18-22

Painting No. 6

The Marriage at Cana

The wedding at Cana was a turning point in the life of our Lord Jesus Christ. Many people were invited. It was a social event. At that time the wedding celebrations could go on for several days. It is important to know that it would have been a public disgrace and shameful for the host to run out of food or wine.

John 2:1-11

1 On the third day a wedding took place at Cana in Galilee. Jesus' mother was there,

2 and Jesus and his disciples had also been invited to the wedding.

3 When the wine was gone, Jesus' mother said to him, "They have no more wine."

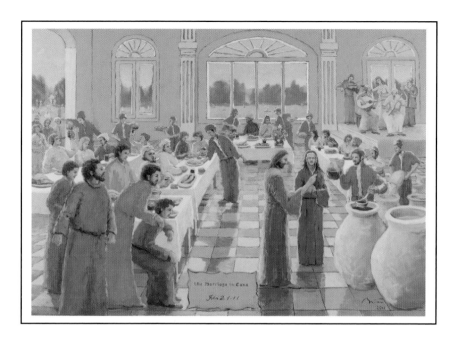

4 "Woman, why do you involve me?" Jesus replied. "My hour has not yet come."

5 His mother said to the servants, "Do whatever he tells you."

6 Nearby stood six stone water jars, the kind used by the Jews for ceremonial washing, each holding from twenty to thirty gallons.

7 Jesus said to the servants, "Fill the jars with water"; so they filled them to the brim.

8 Then he told them, "Now draw some out and take it to the master of the banquet." They did so,

9 and the master of the banquet tasted the water that had been turned into wine. He did not realize where it had come from, though the servants who had drawn the water knew. Then he called the bridegroom aside

10 and said, "Everyone brings out the choice wine first and then the cheaper wine after the guests have had too much to drink; but you have saved the best till now."

11 What Jesus did here in Cana of Galilee was the first of the signs through which he revealed his glory; and his disciples believed in him.

Jesus was not sure that His hour had come. On the other hand, his mother, Mary, was confident. She knew that he was ready, otherwise she would not have said to him, "They have no more wine," which was a prompt for him perform a miracle. When Jesus replied, "Woman, why do you involve me? My hour has not yet come," was proof that He was not convinced. His answer was neither rude nor disrespectful. When he called His mother "Woman" he was using a title of respect that was commonly used at that time. Mary was not convinced when Jesus replied, " My hour has not yet come." That is why she instructed the servants "Do whatever He tells you." At this moment Jesus could have hesitated because of the possibility of disappointing His new disciples (Peter, Andrew, John, James, and Phillip) who were in attendance if the miracle failed to appear. But without any hesitation Jesus said to the servants, "Fill the jars with water," and the miracle happened the moment he said, "Now draw some out and take it to the master of the banquet."

Painting No. 7

Jesus Resurrects a Widow's Son

This is the first of three people Jesus will raise from the dead. When Jesus raises Lazarus', the body was dead for four days before Jesus raised him. It does not matter to God how long the person has been dead. He can bring back to life all those who have died, no matter how or when they died. In Matthew 27: 50-53, *"The bodies of many holy people who had died were raised to life. They came out of the tombs after Jesus's resurrection and went into the holy city and appeared to many people"*

Luke 7: 11-17

11 Soon afterward, Jesus went to a town called Nain, and his disciples and a large crowd went along with him.

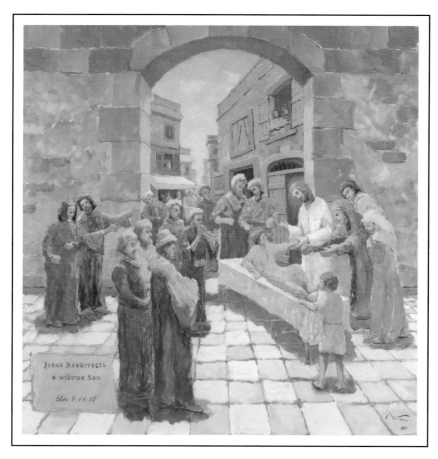

12 As he approached the town gate, a dead person
was being carried out—the only son of his mother,
and she was a widow. And a large crowd from the
town was with her.

13 When the Lord saw her, his heart went out to her and he said, "Don't cry."

14 Then he went up and touched the bier they were carrying him on, and the bearers stood still. He said, "Young man, I say to you, get up!"

15 The dead man sat up and began to talk, and Jesus gave him back to his mother.

16 They were all filled with awe and praised God. "A great prophet has appeared among us," they said. "God has come to help his people."

17 This news about Jesus spread throughout Judea and the surrounding country.

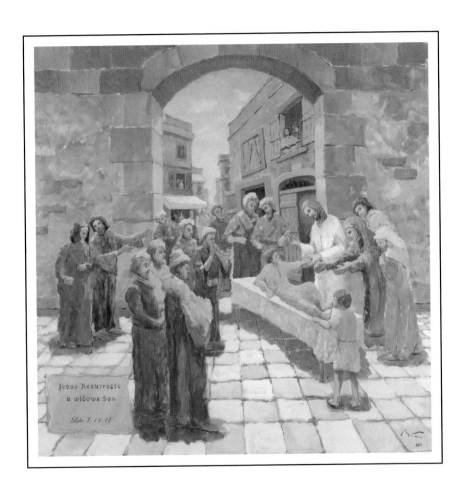

Jesus Resurrects
a Widows Son

Luke 7:11-17

Painting No. 8

Feeding 5,000 People

John 6: 1-15

1 Some time after this, Jesus crossed to the far shore of the Sea of Galilee (that is, the Sea of Tiberias),

2 and a great crowd of people followed him because they saw the signs he had performed by healing the sick.

3 Then Jesus went up on a mountainside and sat down with his disciples.

4 The Jewish Passover Festival was near.

5 When Jesus looked up and saw a great crowd coming toward him, he said to Philip, "Where shall we buy bread for these people to eat?"

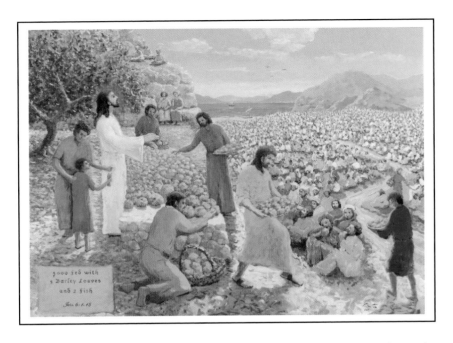

6 He asked this only to test him, for he already had in mind what he was going to do.

7 Philip answered him, "It would take more than half a year's wages to buy enough bread for each one to have a bite!"

8 Another of his disciples, Andrew, Simon Peter's brother, spoke up,

9 "Here is a boy with five small barley loaves and two small fish, but how far will they go among so many?"

10 Jesus said, "Have the people sit down." There was plenty of grass in that place, and they sat down (about five thousand men were there).

11 Jesus then took the loaves, gave thanks, and distributed to those who were seated as much as they wanted. He did the same with the fish.

12 When they had all had enough to eat, he said to his disciples, "Gather the pieces that are left over. Let nothing be wasted."

13 So they gathered them and filled twelve baskets with the pieces of the five barley loaves left over by those who had eaten.

14 After the people saw the sign Jesus performed, they began to say, "Surely this is the Prophet

who is to come into the world."

15 Jesus, knowing that they intended to come and make him king by force, withdrew again to a mountain by himself.

Jesus performed many miracles during the three short years of His ministry. Several times He withdrew Himself from the crowd immediately after performing the miracle. The reason is that the people discovered in Him the Messiah and wanted Him to become their king in Israel. The problem was that they misunderstood the real mission of the coming of the Messiah. It is true that the prophets spoke about Him as the ruler of Israel or as a king, but they were speaking about His Kingdom in Heaven. The mission of the Messiah was to save His people from eternal death by showing them the way to eternal life. As a Lamb of God He came to be crucified on the cross and by shedding His blood He washed away their sins. Being Himself the Eternal Life and by giving His life, Jesus has given to each one of us the

opportunity to have eternal life if we believe in Him.

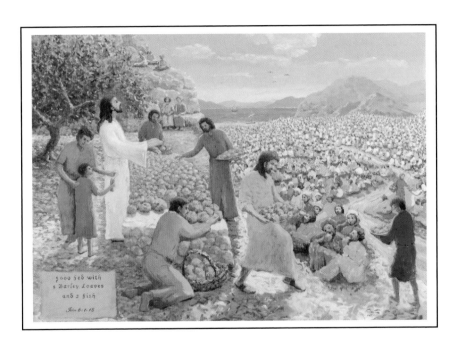

5000 fed with
5 Barley Loaves
and 2 fish
John 6:1-15

The Last Supper

Matthew 26:17-29

17 On the first day of the Festival of Unleavened Bread, the disciples came to Jesus and asked, "Where do you want us to make preparations for you to eat the Passover?"

18 He replied, "Go into the city to a certain man and tell him, 'The Teacher says: My appointed time is near. I am going to celebrate the Passover with my disciples at your house.'"

19 So the disciples did as Jesus had directed them and prepared the Passover.

20 When evening came, Jesus was reclining at the table with the Twelve.

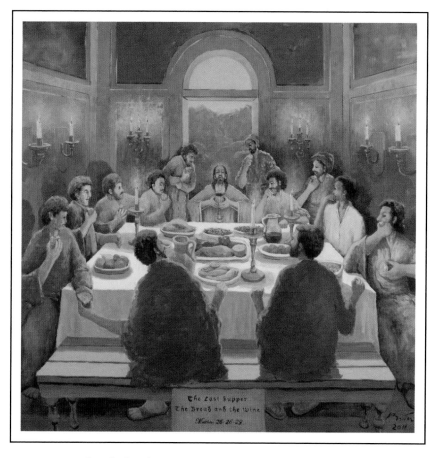

21 And while they were eating, he said, "Truly I tell you, one of you will betray me."

22 They were very sad and began to say to him one after the other, "Surely you don't mean me, Lord?"

23 Jesus replied, "The one who has dipped his hand into the bowl with me will betray me.

24 The Son of Man will go just as it is written about him. But woe to that man who betrays the Son of Man! It would be better for him if he had not been born."

25 Then Judas, the one who would betray him, said, "Surely you don't mean me, Rabbi? Jesus answered, "You have said so."

26 While they were eating, Jesus took bread, and when he had given thanks, he broke it and gave it to his disciples, saying, "Take and eat; this is my body."

27 Then he took a cup, and when he had given thanks, he gave it to them, saying, "Drink from it, all of you.

28 This is my blood of the covenant, which is poured out for many for the forgiveness of sins.

29 I tell you, I will not drink from this fruit of the vine from now on until that day when I drink it new with you in my Father's kingdom."

This is called the Last Supper because it was the last meal Jesus Christ had with His disciples prior to His arrest, crucifixion, death, resurrection, and ascension to Heaven. It was also His last meal prior to finishing His mission on earth, which was to shed His blood on the cross to wash all human sins away. It was during this meal that Jesus provided hope to His followers when He said, *"I confer on you a Kingdom, just as my Father conferred one on me, so that you may eat and drink at my table..."* (Luke 22: 29-30). It was also during this meal that Jesus gave to His followers a remembrance for His body and His blood sacrificed on behalf of all mankind. Over one billion Christians celebrate the Eucharist (Holy Communion) in their churches in accordance with Jesus' instructions at the Last Supper.

Painting No. 10

Gethsemane: The Betrayal by Judas

Matthew 26: 36-48

36 *Then Jesus went with his disciples to a place called Gethsemane, and he said to them, "Sit here while I go over there and pray."*

37 *He took Peter and the two sons of Zebedee along with him, and he began to be sorrowful and troubled.*

38 *Then he said to them, "My soul is overwhelmed with sorrow to the point of death. Stay here and keep watch with me."*

39 *Going a little farther, he fell with his face to the ground and prayed, "My Father, if it is possible, may this cup be taken from me. Yet not as I will, but as you will."*

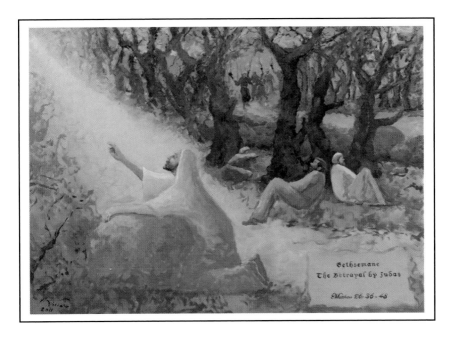

Gethsemane
The Betrayal by Judas

Matthew 26: 36 - 48

40 *Then he returned to his disciples and found them sleeping. "Couldn't you men keep watch with me for one hour?" he asked Peter.*

41 *"Watch and pray so that you will not fall into temptation. The spirit is willing, but the flesh is weak."*

42 *He went away a second time and prayed, "My Father, if it is not possible for this cup to be taken away*

unless I drink it, may your will be done."

43 *When he came back, he again found them sleeping, because their eyes were heavy.*

44 *So he left them and went away once more and prayed the third time, saying the same thing.*

45 *Then he returned to the disciples and said to them, "Are you still sleeping and resting? Look, the hour has come, and the Son of Man is delivered into the hands of sinners.*

46 *Rise! Let us go! Here comes my betrayer!"*

47 *While he was still speaking, Judas, one of the Twelve, arrived. With him was a large crowd armed with swords and clubs, sent from the chief priests and the elders of the people.*

48 *Now the betrayer had arranged a signal with them: "The one I kiss is the man; arrest him."*

The big questions about Judas' betrayal are:

Question: Is Judas responsible for his act?

Answer: Yes. At the Last Supper (Matthew 26:24) Jesus said, *"But woe to that man who betrays the Son of Man! It would be better for him if he had not been born."*

Question: But at the beginning of that same verse (Matthew 26:24) Jesus also said, *"The Son of Man will go just as it is written about Him."* This looks like it was written, therefore it has to happen no matter what.

Answer: It is true that God knew about the betrayal of Judas. As a matter of fact, He knew about it before Judas was born. We have to remember that God is out of the realm of time and space. He knows every detail of what each one of us will be doing in the future. But we must not confuse between

God knowing it and God doing it. God gave us a freewill that He will never alter. This freewill was given to Judas like any of us. Judas chose to betray Jesus and God knew this as He caused it to be written. God could have stopped Judas, but, He would then have broken the covenant of freewill which He gave to us and this He will never do.

Question: Does this mean that we must not believe in our destiny?

Answer: Our destiny depends on us to a certain extent, because we have no control over accidents, natural disasters, wars, or any other catastrophic uncontrolled events in the future. But everything we do willingly contributes to our destiny. God knows indeed our destiny, but He does not interfere in our decisions. He gave us a freewill that He will always respect.

Gethsemane
The Betrayal by Judas

Matthew 26: 36 - 46

Painting No. 11

The Humiliation of Jesus

John 19:1-16

1 Then Pilate took Jesus and had him flogged.

2 The soldiers twisted together a crown of thorns and put it on his head. They clothed him in a purple robe

3 and went up to him again and again, saying, "Hail, king of the Jews!" And they slapped him in the face.

4 Once more Pilate came out and said to the Jews gathered there, "Look, I am bringing him out to you to let you know that I find no basis for a charge against him."

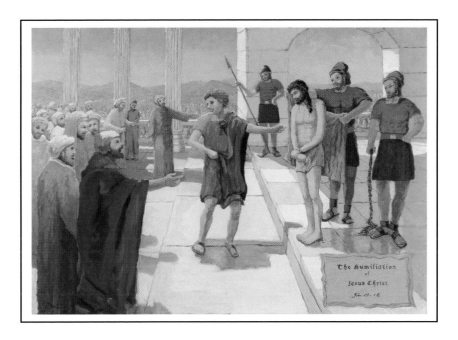

The Humiliation of Jesus Christ
John 19: 1-6

5 *When Jesus came out wearing the crown of thorns and the purple robe, Pilate said to him, "Here is the man!"*

6 *As soon as the chief priests and their official saw him, they shouted, "Crucify! Crucify! "But Pilate answered, "You take him and crucify him. As for me, I find no basis for a charge against him."*

7 *The Jewish leaders insisted, "We have a law, and*

according to that law he must die, because he claimed to be the Son of God."

8 *When Pilate heard this, he was even more afraid,*

9 *and he went back inside the palace. "Where do you come from?" he asked Jesus, but Jesus gave him no answer.*

10 *"Do you refuse to speak to me?" Pilate said. "Don't you realize I have power either to free you or to crucify you?"*

11 *Jesus answered, "You would have no power over me if it were not given to you from above. Therefore the one who handed me over to you is guilty of a greater sin."*

12 *From then on, Pilate tried to set Jesus free, but the Jewish leaders kept shouting, "If you let this man go, you are no friend of Caesar. Anyone who claims to*

be a king opposes Caesar."

13 When Pilate heard this, he brought Jesus out and sat down on the judge's seat at a place known as the Stone Pavement (which in Aramaic is Golgotha).

14 It was the day of Preparation of the Passover; it was about noon. "Here is your king," Pilate said to the Jews.

15 But they shouted, "Take him away! Take him away! Crucify him!" "Shall I crucify your king?" Pilate asked. "We have no king but Caesar," the chief priests answered.

16 Finally Pilate handed him over to them to be crucified. So the soldiers took charge of Jesus.

Following are some prophesies from the Old Testament several hundred years before Christ in regard to the Humiliation.

Isaiah 50:6: *I offered my back to those who beat me, my cheeks to those who pulled out my beard; I did not hide my face from mocking and spitting.*

Isaiah 53:7: *He was oppressed and afflicted, yet he did not open his mouth; he was led like a lamb to the slaughter, and as a sheep before its shearers is silent, so he did not open his mouth.*

Isaiah 53:5: *But he was pierced for our transgressions; he was crushed for our iniquities; the punishment that brought us peace was on him, and by his wounds we are healed.*

Jesus taught us through His humiliation:

- That the way to conquer evil is through good

- Violence can only be overcome by non-violence

- Hatred can be stopped through love

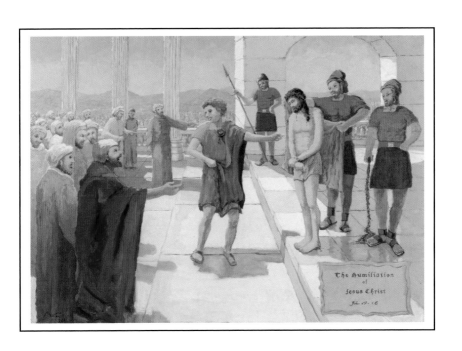

The Humiliation
of
Jesus Christ
John 19. 16

Crucifixion and Death of Jesus

John 19: 16-27

16 Finally Pilate handed him over to them to be crucified. So the soldiers took charge of Jesus.

17 Carrying his own cross, he went out to the place of the Skull (which in Aramaic is called Golgotha).

18 There they crucified him, and with him two others—one on each side and Jesus in the middle.

19 Pilate had a notice prepared and fastened to the cross. It read: JESUS OF NAZARETH, THE KING OF THE JEWS.

20 Many of the Jews read this sign, for the place where Jesus was crucified was near the city, and the

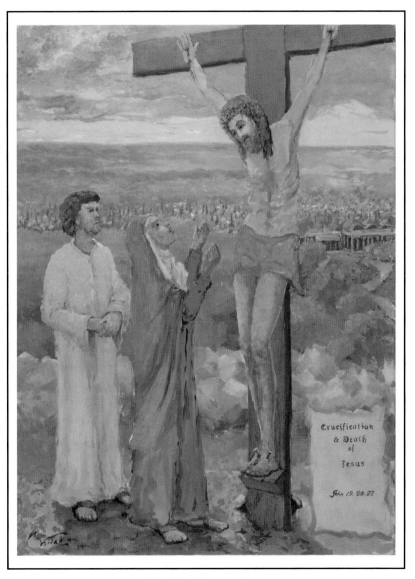

Crucifixion
& Death
of
Jesus

John 19. 25-27

The Life of Our Lord 137

sign was written in Aramaic, Latin and Greek.

21 *The chief priests of the Jews protested to Pilate, "Do not write 'The King of the Jews,' but that this man claimed to be king of the Jews."*

22 *Pilate answered, "What I have written, I have written."*

23 *When the soldiers crucified Jesus, they took his clothes, dividing them into four shares, one for each of them, with the undergarment remaining. This garment was seamless, woven in one piece from top to bottom.*

24 *"Let's not tear it," they said to one another. "Let's decide by lot who will get it." This happened that the scripture might be fulfilled that said, "They divided my clothes among them and cast lots for my garment." So this is what the soldiers did.*

25 *Near the cross of Jesus stood his mother, his*

mother's sister, Mary the wife of Clopas, and Mary Magdalene.

26 *When Jesus saw his mother there, and the disciple whom he loved standing nearby, he said to her, "Woman*, here is your son,"*

27 *and to the disciple, "Here is your mother." From that time on, this disciple took her into his home.*

* The greek for Woman does not denote any disrespect.

What sorrow must fill Mary's heart to see her son mocked, tortured, and now crucified. Once again a sword pierces Mary's soul, as prophesied by Simon at the Temple (Luke 2:35).

John 19:26-27 is a very important passage for two reasons.

1. It is a proof that Jesus was the only child of Mary, because if he did have brothers or sisters, they

would have provided for her and would have at least accompanied her to Jesus' crucifixion.

2. It is also an important passage because it was the third of the last seven expressions (words of Jesus on the cross.) The importance of this third expression goes beyond Jesus worry about somebody to take care of His mother when He said to her "This is your son" and to John "This is your mother." No one can believe that almighty God is not powerful enough to take care of His mother. The only logical explanation left is that Jesus, because of his mercy to us and especially to those who have lost their mothers, or are missing a mother, gave us consolation by knowing that what Jesus said to John is meant to also be for each of us. Mary is our mother.

It is true that the Blessed Virgin Mary is not divine because she was created like all of us. However, she is not an ordinary woman for the following reasons.

1. God cannot cohabit with a sinner. We all know from the bible the story of the fallen angel, better known as Satan (see Isaiah 14:12-15). If God had cast down to earth Satan and his followers it is precisely because Satan committed the first sin, which was envy, by a creature of God's creation. This is to say that God would not have chosen a woman who was a sinner to carry Him in her womb during her pregnancy.

2. In the Annunciation (see Painting No.1) (Luke 1:26-38) the angel Gabriel told her, *"Greetings, you who are highly favored (blessed among women) the Lord is with you."*

A Prayer for Forgiveness

Dear Almighty and Holy God,

You humbled yourself and became human in Jesus Christ. Your Celestial light came to enlighten the darkness of our souls and hearts to save us from eternal death. We, instead of glorifying your presence here on earth among us, despised and rejected you and crucified you on a cross. Until now we crucify you everyday by disobeying your commandments. But, with your endless love and forgiveness you accepted to shed your blood on the cross to cleanse all our sins.

Father, I have hurt you by neglecting your commandments with my acts, deeds, thoughts, and speech. I know that I do not deserve your mercy. I ask you God that you forgive me of my sins known and unknown. I ask you Jesus to come into my heart as my savior. I ask that from this moment you direct me. From this day I pledge to hear your voice and obey your commandments.

Thank you Jesus for the eternal life that you gave me when you shed your blood on the cross.

<div align="right">AMEN</div>

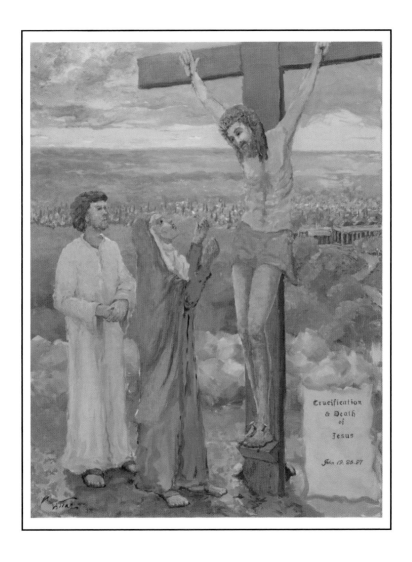

Crucifixion
& Death
of
Jesus

John 19. 25-27

Painting No. 13

The Resurrection of Jesus

The Prophecy of the Burial of Jesus

Isaiah 53:9: *He was assigned a grave with the wicked, and with the rich in his death...*

The above prophecy which was announced 700 years before Jesus' death was fulfilled in Matthew 27:57-60.

57 *As evening approached, there came a rich man from Arimathea, named Joseph, who had himself become a disciple of Jesus.*

58 *Going to Pilate, he asked for Jesus' body, and Pilate ordered that it be given to him.*

59 *Joseph took the body, wrapped it in a clean linen cloth,*

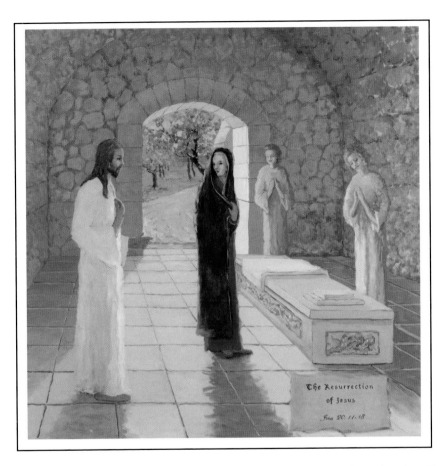

60 *and placed it in his own new tomb that he had cut out of the rock. He rolled a big stone in front of the entrance to the tomb and went away.*

John 20:11-18

11 *Now Mary (Mary Magdalene) stood outside the tomb crying. As she wept, she bent to look into the tomb*

12 *and saw two angels in white, seated where Jesus' body had been, one at the head and the other at the foot.*

13 *They asked her, "Woman, why are you crying?" "They have taken my Lord away," she said, "and I don't know where they have put him."*

14 *At this, she turned around and saw Jesus standing there, but she did not realize that it was Jesus.*

15 *He asked her, "Woman, why are you crying? Who is it you are looking for?" Thinking he was the gardener, she said, "Sir, if you have carried him away, tell me where you have put him, and I will get him."*

16 Jesus said to her, "Mary." She turned toward him and cried out in Aramaic, "Rabboni!" (which means "Teacher").

17 Jesus said, "Do not hold on to me, for I have not yet ascended to the Father. Go instead to my brothers and tell them, 'I am ascending to my Father and your Father, to my God and your God.'"

18 Mary Magdalene went to the disciples with the news: "I have seen the Lord!" And she told them that he had said these things to her.

Painting No. 14

The Ascension of Jesus Christ

The Ascension implies Jesus' humanity being taken into heaven. His ascension occurred 40 days after His resurrection. He spent these 40 days teaching his followers. He told his Apostles that they would receive the power of the Holy Spirit and they would spread His message the world over.

Luke 24:50-53

50 When he had led them out to the vicinity of Bethany, he lifted up his hands and blessed them.

51 While he was blessing them, he left them and was taken up into heaven.

52 Then they worshiped him and returned to Jerusalem with great joy.

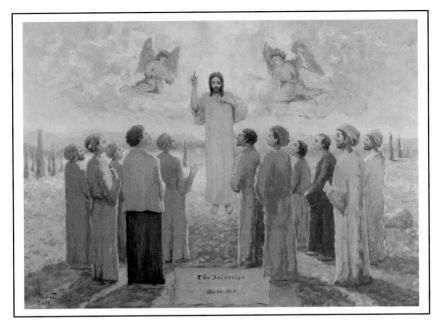

53 And they stayed continually at the temple, praising God.

The End of Time

At the end of time, which is near, those who died in Christ as well as those who are still living and believe that Jesus Christ is our God and Savior, that he died and rose on the third day from the dead and ascended to heaven, will also ascend with their body

and meet the Lord. Here is what the Bible states:

1 Thessalonians 4:16-17:

16 *For the Lord himself will come down from heaven, with a loud command, with the voice of the archangel and with the trumpet call of God, and the dead in Christ will rise first.*

17 *After that, we who are still alive and are left will be caught up together with them in the clouds to meet the Lord in the air. And so we will be with the Lord forever.*

Many prophesies about Christ's death and resurrection were also fulfilled, for example:

Matthew 12:40:

For as Jonah was three days and three nights in the belly of a huge fish, so the Son of Man will be three days and three nights in the heart of the earth.

Jesus' disciples seem to have forgotten what Jesus told them in regard to His resurrection.

In John 2:18-19: *The Jews then responded to him, "What sign can you show us to prove your authority to do all this?" Jesus answered them, "Destroy this temple, and I will raise it again in three days."*

By temple Jesus meant His body, and by destroying it He meant killing Him, and He raised it up by His resurrection.

In Matthew 16:21: *From that time on Jesus began to explain to his disciples that he must go to Jerusalem and suffer many things at the hands of the elders, the chief priests and the teachers of the law, and that he must be killed and on the third day be raised to life.*

In Matthew 17:22-23: Jesus predicted, for the second time, His death and resurrection. *When they came together in Galilee, he said to them, "The Son*

of Man is going to be delivered into the hands of men. *They will kill him, and on the third day he will be raised to life." And the disciples were filled with grief.*

Also, in Matthew 20:17-19, Jesus predicted, for the third time, his death and resurrection. *Now Jesus was going up to Jerusalem. On the way, he took the twelve aside and said to them, "We are going up to Jerusalem, and the Son of Man will be delivered over to the chief priests and the teachers of the law. They will condemn him to death and will hand him over to the Gentiles to be mocked and flogged and crucified. On the third day he will be raised to life!"*

Hopefully, we won't forget and will always believe in the death and the resurrection of Jesus Christ, because this belief is necessary for our salvation, and emphasized by the following verse.

Romans 10:9: *"If you declare with your mouth, "Jesus is Lord," and believe in your heart that God raised him from the dead, you will be saved."*

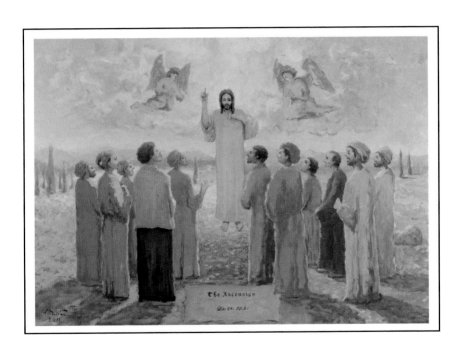

The Ascension

Lu 24. 50.51

Chapter 5

Behind the Scenes

This chapter explains for each painting the composition, the difficulties encountered, and how the solutions were inspired.

Some of the details of each painting have been enlarged and analyzed separately to unveil what may not have been immediately visible to the eyes.

Most old biblical paintings were not explained by the artist, and viewers are left wondering what the artist meant to convey. Some paintings have been commented on by writers or art critics, but those opinions were guesses rather than facts. This chapter will certainly be appreciated in the future.

1) The Annunciation

The Composition

The scripture does not specify what Mary was doing when the Angel visited her. After some meditation I decided to have her standing near an open window. I wanted to show her reading some verses from the Bible. The room is simple and modest. All the furniture is made from wood, as is the ceiling. This is an invitation to guess that her fiancé Joseph, who was a carpenter, did this for her. The

position of the angel is opposite to Mary. However, I wanted to show both of their faces in the painting. The choice of Mary's and the angel's dress was to have a color which would complement the decoration of the room.

Difficulties and Solutions.

The first difficulty was to give Mary an expression on her face which will correspond to the Gospel scripture showing her: a) troubled b) wonderingc) unafraid d) surprised e) submissive. A lot of expressions combined which is not easy to paint without a model in front of me. Even with a model, that model would have to be a great actor. While trying to paint Mary's face I was amazed to see how easy it came out. All the praise to the Lord.

Another difficulty was to determine the position of the sun hitting the room floor. From the window sill you can see how the light was coming with about a 45 degree angle from the window. Where should that light be on the floor, closer or further away from the window? Is it at the center of

the room? If yes, where exactly? How big should it be? It looks easy when the painting is done, but to do it, I was struggling. God

helped me. How? He asked me to take a cardboard shoe box and cut one of its sides as a window and bend the cardboard on the inside of the box to

simulate the depth of the wall. Then I put the box under a 45 degree light from above and noted the shape of the light and its location on the simulated floor.

Miracle or Coincidence

On my original sketch I drew the shape of the book stand covered by a scroll. I left the scroll without anything written on it. When the time came to fill that area of the scroll which is visible between Mary's left arm and shoulder, I was inspired to write something in Hebrew. But I do not know Hebrew, neither did I know what to write. I undertook to do some research on the internet and I found a bible in Hebrew with the English translation on the opposite page. In Isaiah's prophecy (Isaiah 7:14):

Therefore the Lord himself will give you a sign: The virgin will conceive and give birth to a son, and will call him Immanuel.*

(*Immanuel means the "God is with us")

I was inspired to choose that prophecy and write it on that visible space of the scroll. My big surprise was that when I started copying the verse

it filled perfectly the empty space of the scroll. Not a place left to add a single letter.

All the Glory to God for His inspiration and help.

2) The Birth of Jesus

The Composition

I was very inspired to do this composition; the stable with some animals, the shepherds with their children, a young boy carrying a lamb, another boy, curious, held by his father. All with different expressions.

I was also inspired to paint an open window on the back wall, although it is not in my original sketch.

Light is coming from the window and was directed exactly over Jesus. His mother and Joseph are also visible and are bathed in that light.

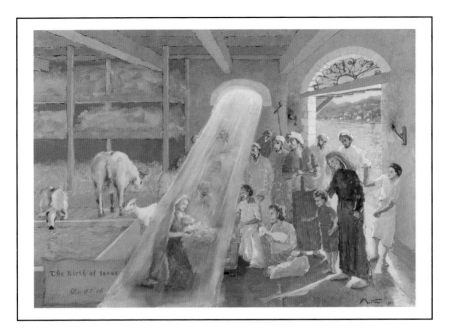

I was very happy with the last minute thought which brought to the subject that majestic feeling around the Holy family. All the Glory to God.

3) The Flight into Egypt

The Composition

I tried to imagine how the Holy family managed such a long trip. Logically they would have used a donkey that Mary, holding Jesus in her arms, was riding and Joseph led the donkey with a rope with his right hand and held a small bag as luggage in his left hand.

The expression of Mary watching Jesus is full of love and happiness and Joseph's expression watching them is kind and peaceful.

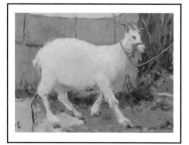

A female goat is attached to the back of the donkey and certainly helped feed the family during this trip.

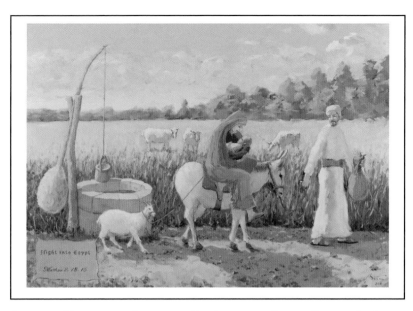

The well near the road shows that they did not

suffer from thirst. The green field behind them shows that they were in a country which was welcoming and rich in agriculture. The sun shining indicates that the climate in this new country was agreeable.

All the Glory to Jesus for His inspiration and help.

4) At the Temple

The Composition

I wanted to have a general view that showed Jesus sitting among the religious teachers but also includes Mary and Joseph from a distance. I had to imagine myself painting the scene from a higher position which can cover a larger perspective. To discover how the temple may have looked on the inside, I was inspired by the first book of Kings speaking about the two cherubs on the temple, the palm tree decoration, as well as the narrow windows on the high walls near the ceiling.

In Luke 2:47 it says, *"All who heard Him were amazed at his understanding and His answers."* All the religious teachers are listening and looking at Him, one is taking notes, two others are wondering about the young 12 year old boy.

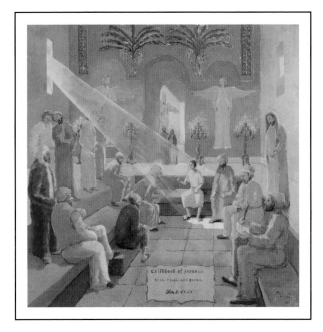

You can feel from the expression on the faces how much they were enjoying Jesus' company. Here I also used the sun coming from the window

over Jesus to make Him the focus. All the Glory to Jesus for His inspiration and help.

5) The First Four Disciples

Composition

This was my first painting in this series. In order to show in one painting the whole story, I decided to have in the foreground the end of verse 22 of Matthew 4 when the two sons, James and John,

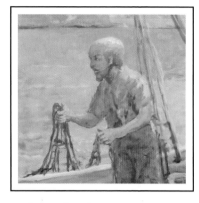

left their father Zebedee behind in the boat. You can see from Zebedee's expression that he is astonished.

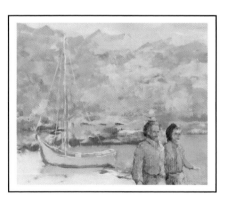

In the background is the beginning of the story when Jesus met Peter and his brother Andrew and He called them to follow Him in verse 18 and 19. Between the two you see what is in verse 21 when Jesus invited the two brothers John

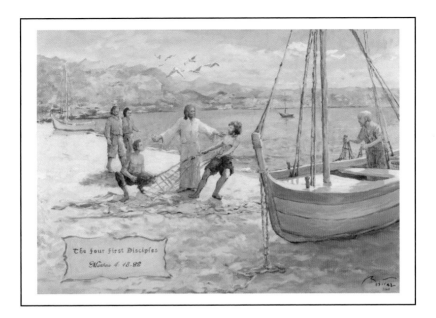

The Four First Disciples
Matthew 4:18-22

and James.

Notice the welcoming gesture of Jesus opening His arms. It was only when I finished the painting that I was inspired to add the seven seagulls above Jesus's head.

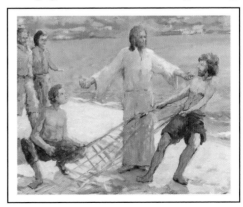

All the Glory to God for His inspiration and help.

6) The Marriage in Cana

The Composition

In order to be able to capture everything that was happening in this heavily populated social event, I had to imagine that I was painting it from an elevated place so that I could obtain a larger perspective allowing me to show everything. The

bride and the groom are occupying the center place at the end of the big room and are being served by two servants. You can also notice through the large window behind them more guests walking in the host's garden indicating how crowded the party was. In the right corner of the big room you can see a band playing, entertaining the wedding using instruments that belonged to that time in history.

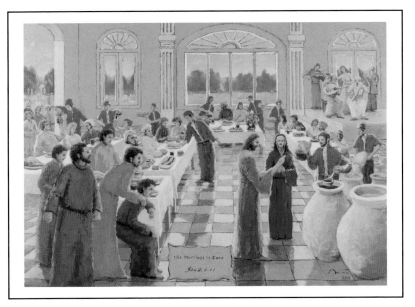

There is a lot of action happening. Some servants pouring wine, some others serving food. Most of the food was based on fish, lamb, and fowl.

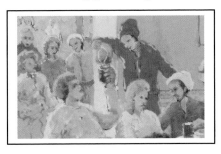

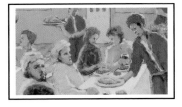

The drinks were mainly wine, which was consumed on a large scale.

In the left corner of the painting you see the garden with more people coming to join the party.

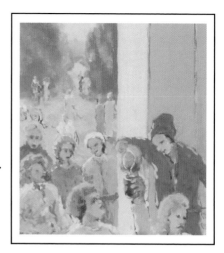

As mentioned in the second verse of John chapter 2, Jesus' disciples had also been invited. You can see Peter in a blue robe and his brother Andrew behind him. James can be seen with his hand over his brother John's shoulder. You also see Philip standing

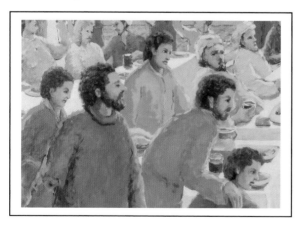

between Peter and James. These were the five disciples that Jesus had assembled at this early stage of His ministry.

The Problem and Solution

The miracle of changing the water into wine is a story which has many events. After Mary, Jesus' mother, told Him that they had no more wine, Jesus told the servants to fill with water the six large jars which can contain 26 gallons each.

The problem was to show the miracle happening. I was inspired to show five of the six jars

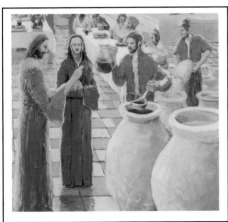

filled with water and the sixth jar, which was in front of Jesus, was the only one so far which had been transformed to wine after Jesus had blessed it.

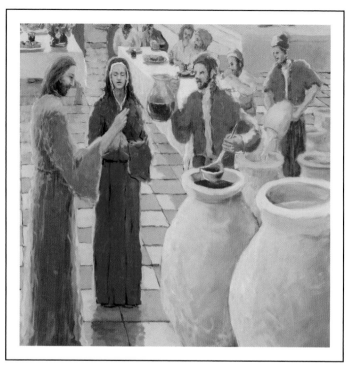

To emphasize the fact that the transformation is to
wine, a servant is pouring in a transparent carafe the
wine obtained from that jar. The difference between
the five jars and the one that Jesus blessed shows the
miracle happening, and allows the viewers of this
painting to understand that the next step will be the
transformation of the water in the other jars to wine
also.

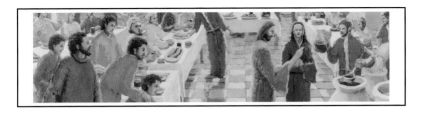

The five disciples were behind Jesus watching carefully with astonishment this first miracle that He performed.

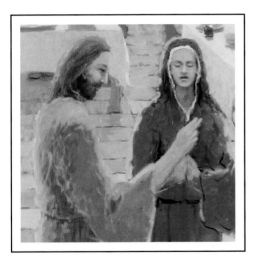

During the blessing you can see His mother standing near Him watching the first miracle by her son.

All the Glory to Jesus for His inspiration and help.

7) Jesus Resurrects a Widow's Son

The Composition

I have several times painted scenes of old villages in the south of France and Italy. I have also visited the Middle East. The composition was executed without any difficulty. The town gate helped to separate Jesus and the public who were around Him. This allowed a large place in the foreground of the painting for the miraculous scene.

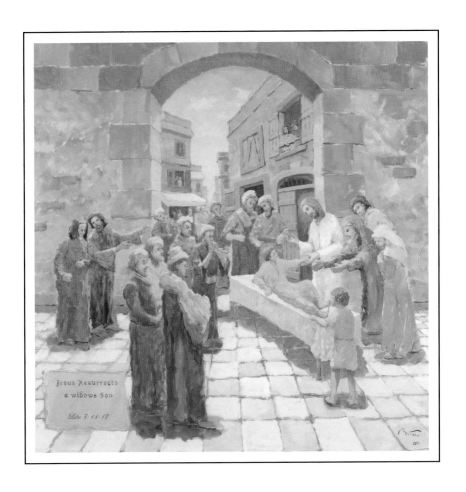

Jesus Resurrects
a Widows Son

Luke 7:11-17

Difficulties and Solutions

People were surrounding Jesus. They were observing Him with a variety of expressions on their faces.

Curious

Wondering

Amazed

With Faith

Explaining

Happy

Like all of the other paintings of the Life of Our Lord, I was helped by inspirations and my hand was guided miraculously. The expression on Jesus face when He was saying to the dead boy, "Young man, I say to you get up," shows a wealth of love and kindness.

 The emotion expressed on the face of the boy's mother, as well as some of his relatives, gives to the subject a great feeling of praise and recognition.

All the Glory to Jesus for His inspiration and help.

8) Feeding 5,000 People

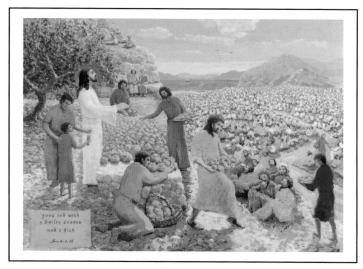

The Composition

In order to see a maximum number of people out of the 5,000 families, and see in detail Jesus performing the miracle, the painting had to be done from the perspective of Jesus on the mountain.

From that perspective we can also see the Sea of Tiberias surrounded by hills, as well as the boat beached on the shore.

Some curious kids chose to climb rocks to view the scene from above in order to follow in detail the succession of the multiplication of the bread as well as the fish.

The elevation where Jesus is standing is emphasized by his disciples carrying the bread downhill. You will also note the path is sloping down between the crowd.

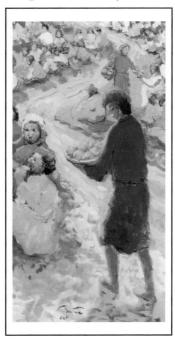

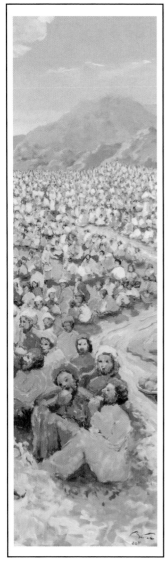

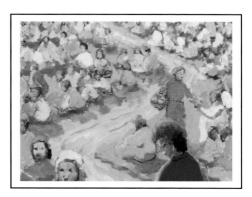

The bible says, "there was plenty of grass in that place and they sat down."

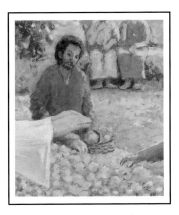

Around Jesus the disciples were filling their baskets with the multiplied bread and carrying it to the hungry people all around the area.

The problem and solution

The subject of the painting is a series of events that all have to be portrayed in the painting.

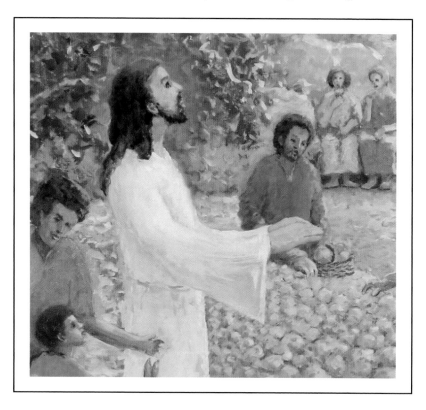

First it was the bread that Jesus multiplied out of the five small barley loaves while blessing it and giving thanks.

To show continuity of action in regard to the multiplication of the fish, the young boy who brought the five loaves of bread and was observing the miracle was willing to give the two fish to Jesus so He can also multiply them. Andrew, the disciple who discovered the boy, was holding him back until the multiplication of the bread miracle was complete.

All the Glory to Jesus for His inspiration and help.

9) The Last Supper

The composition

The atmosphere was tense after Jesus announced that He will be betrayed by one of His 12 disciples.

The celebration of Passover was in a room of someone designated by Jesus. It was very cozy and the disciples were gathered around a square table.

It was at the end of the day and candles were lighting the room. The sky shows it was twilight.

Four of the disciples were near Jesus. Two were standing behind him and two were seated on each side.

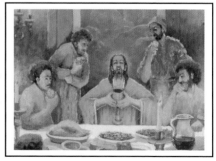

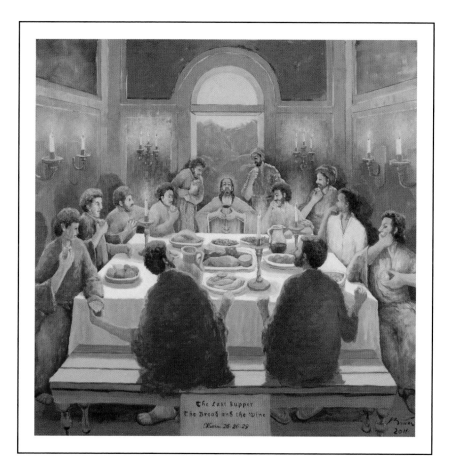

The Last Supper
The Bread and the Wine
Matthew 26:26-29

This made it more difficult for the disciples to guess who the betrayer would be when Jesus said, "The one who dipped his hand into the bowl with me will betray me."

The problem and solution.

How to show on one painting two actions, which are happening sequentially? The first is when He gave the bread to His disciples and told them to eat it, and the second is when He gave to them the cup of wine and told them to drink from it.

Solution

I was inspired to show in the painting six disciples on each side of Jesus. To show that the bread was still in circulation, starting simultaneously, from both sides of Jesus, I depicted the last two sitting on the opposite side of Jesus having not yet received the bread. This shows that the first action had already started. Then Jesus took the cup and while He was giving thanks, which is the second action, the disciples were participating because they were looking at Him. The first five disciples on each side had already received the bread and had started to eat it, and the fifth one, on each side, was just handing the bread to the last disciple. These last two disciples had not yet received the bread.

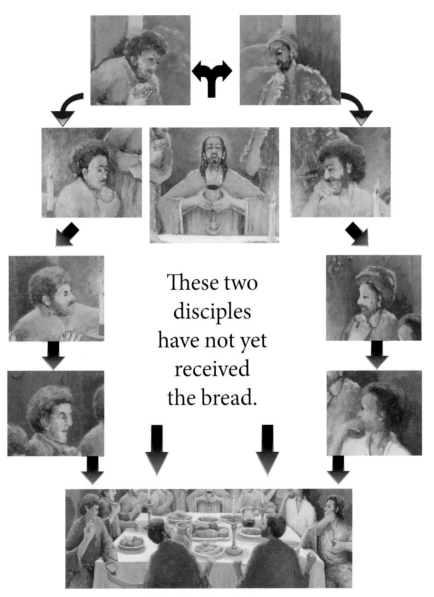

These two
disciples
have not yet
received
the bread.

10) The Betrayal by Judas.

The Composition

The 3 main scenes are shown:
- Jesus praying
- The three disciples Peter, John, and James sleeping
- Judas leading an armed crowd with swords and clubs coming to arrest Jesus

The problem and solution

If the painting was limited to only two scenes, Jesus praying and the disciples sleeping, then there would have been no problem. But the third scene with Judas accompanying the crowd coming to arrest Jesus is also very important.

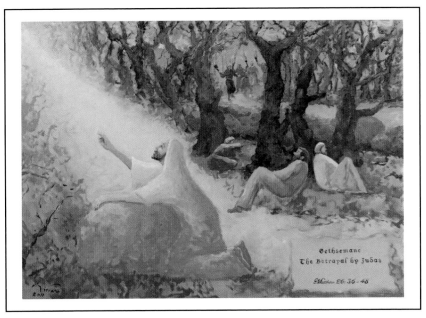

Gethsemane
The Betrayal by Judas

Matthew 26: 36 - 46

If we limit the painting to Jesus waking His disciples and Judas' arrival, it would also have made for an easier painting to do.

But in this case we would not see Jesus praying, which would have been regrettable. The problem is the timing.

It will require several minutes if we analyze all the actions which are happening.

1) The painting shows Jesus at the middle of His prayer. He needs a certain time to finish praying, stand up, walk to His three disciples,

wake them up, tell them, "Are you still sleeping and resting? *Look,... the Son of Man is delivered into the hands of sinners – Rise! Let us go! Here comes my betrayer*"

2) To show clearly in the painting Judas with the crowd they must not be too far. In the painting their distance could be estimated to be 100 feet maximum with their visible speed coming down hill, they would have arrived in a few seconds. So what to do?

Solution

An internal voice told me to have a curve on the road with a wall of large stones separating the road from where Jesus was praying and His disciples

were sleeping, in such a way that they will not be seen. This will delay Judas' arrival although he is visible.

11) The Humiliation of Jesus

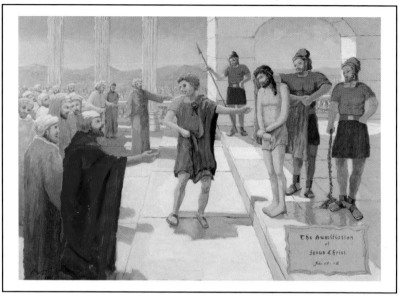

Composition

The humiliation happened in two different places. Before Pilate brought Jesus out to face the Jews gathered there, Jesus was already humiliated inside.

He had been flogged with a metallic-studded whip, and a crown of thorns had been put on his head.

He was bleeding copiously and His blood was covering the floor under Him. They were slapping Him in the face

and mocking Him saying "Hail, king of the Jews" while clothing Him in a robe.

When He was brought before the crowd outside, He was mocked by the soldiers.

He was also confronted by all those tormentors and aggressive Jewish leaders. Pilate told the Jewish crowd, "Here is the man."

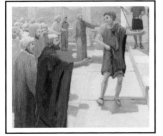

As soon as the chief priests and the Jewish officials saw Jesus, they shouted, "Crucify! Crucify!"

12) Crucifixion and Death

The Composition

The painting shows the cross at the place of the skulls, which in Aramaic is called Golgotha. From that hill you can see the city below and the road connecting it to the Crucifixion ground. No one can imagine the pain and suffering endured by Jesus. The opposite detail helps to understand.

On the cross Jesus pronounced only seven expressions in total. Therefore each utterance must have its importance. The third expression was directed to His mother Mary and to John, His favorite disciple.

This moment is important as is the eye contact between Jesus and His mother. The expressions on

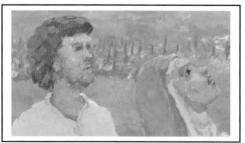

Mary and John's faces are very emotional. With God's help I was able to paint all these expressions.

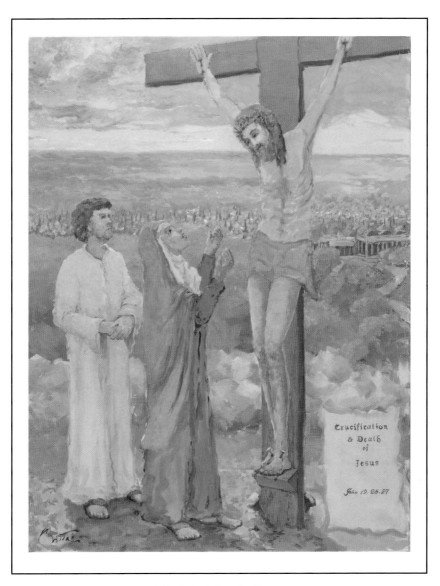

Crucifixion
& Death
of
Jesus

John 19. 26-27

13) The Resurrection of Jesus

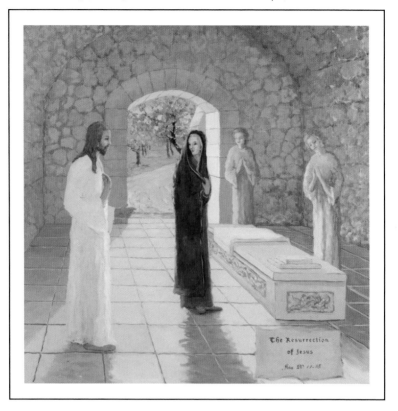

The Resurrection
of Jesus
Joo 20 11-18

The Composition

The tomb was cut out of the rock. The owner was a rich man named Joseph who gave his own tomb to Jesus. The big, heavy round stone to block the tomb entrance can be seen from the inside.

Over the coffin we can see the linen cloth folded. It was Joseph who wrapped Jesus' body with this clean linen cloth after His crucifixion and death. The blossoming trees seen just outside the tomb remind us this was during the spring season. Two angels who were seated on the head and the foot of the coffin stood up when Jesus appeared behind Mary Magdalene.

When she felt that somebody was behind her, she turned around and saw someone. She thought that He was the gardener. When Jesus asked her "Woman, why are you crying? Who is it

that you are looking for?" Mary answered "Sir, if you have carried Him away, tell me where you have put Him, and I will get Him." When Jesus said to her, "Mary," she turned to Him and cried out, "Teacher!

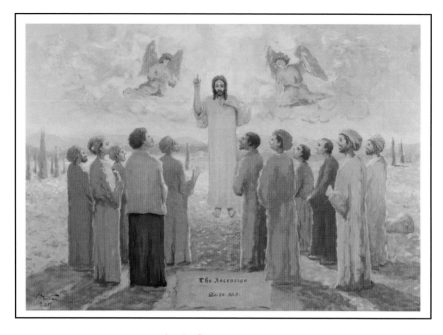

14) The Ascension

The painting is self-explanatory after reading Luke 24:50-51

50 *When he had led them out to the vicinity of Bethany, he lifted up his hands and blessed them.*

51 *While he was blessing them, he left them and was taken up into heaven.*

Here are a enlargements of His 11 disciples' facial expressions. (Judas hanged himself immediately after he betrayed Jesus -Matthew 27:5.)

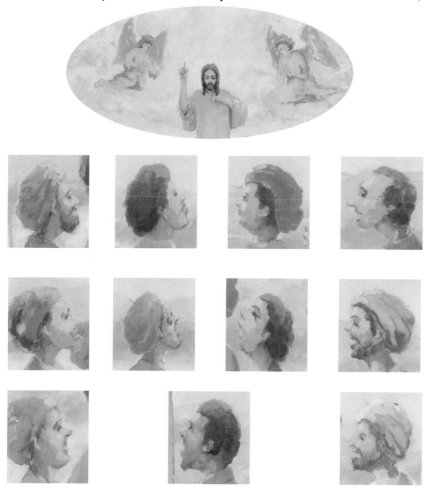

Chapter 6

Questions and Answers

Question 1: What do your paintings bring to biblical art?

Answer 1: I can see two reasons which could be considered unique or unprecedented.

1)Biblical paintings have so far been limited to classic or academic styles. This will be the first time in history that an impressionist artist is painting the Gospel with the vivid colors of the outdoors (plein air).

2)This will be one of the rare art exhibitions illustrating in original paintings the full Life of Our Lord; birth, childhood, ministry, death, resurrection, and ascension by the same artist.

Question 2: You have been a successful impressionist artist. Why did you switch to biblical paintings?

Answer 2: I did not really switch from the impressionist style. I painted "The Life of Our Lord" with the impressionist style. I grew up with this style and it is part of me. I do not feel as though I changed style. I will never change my style. If I started recently to paint biblical paintings it is because Jesus inspired me to do it. I was praying to Him to give me the opportunity to spread His word, when He surprised me by telling me to do it with the talent that He granted me, which is painting.

Question 3: Besides the fact that your impressionist style is new in biblical art, what else new do you think the 21st century can bring to the biblical painting genre?

Answer 3: Without any doubt we are living in an extraordinary time. We are very fortunate. We can have through the Internet and electronic technology, within seconds any part of the world displayed on the computer screen in full color. Artists in the past were relatively isolated from the rest of the world. If you analyze the biblical paintings of the past, you notice that they reflected typical local European landscapes, architecture, people's faces, clothes, furniture, etc., which have nothing in common with the land of Israel or its inhabitants, faces or clothes. You notice these anomalies by looking at the biblical paintings hanging in museums. One example is the depiction of books instead of scrolls. It seems that some artists were not in possession of the bible to read carefully the scripture. As a result, some paintings are lacking

authenticity.

Question 4 : Do you think that biblical artists were all believers, and does it really make any difference if they were believers or not?

Answer 4: Most artists were commissioned by patrons to paint biblical paintings. They were making a living from their art. Some of them might have been believers but certainly many were not. Many wealthy patrons were imposing their desires on the artist, as for instance, using their family as models or imposing their palaces and their furniture on the artist to use in the art. It is obvious that a good artist will transmit his true feelings on his canvas. If he has strong faith it will show; if not, his paintings will not communicate any feelings or emotions.

Question 5: What can biblical paintings bring to the reading of the bible?

Answer 5: We have all heard that a picture is worth a thousand words. Let us first analyze this saying.

5a) Our eyes can encompass in a few seconds the full content of a painting, taking in faster more information than can be had in several minutes of reading. The same is true of listening to a reading from a record or a radio. If you compare the faculty of our sight to our hearing or reading comprehension, you realize that we listen or read sequentially. You cannot by looking at a full newspaper page capture its content in a couple of seconds. Neither by looking at a record can you understand its content.

5b) A painting transmits to your heart the artist's feeling or faith. Reading the Bible transmits first to your mind, but if you have no faith it will not reach your heart.

5c) Having biblical paintings displayed to the public, in a museum, church, or any exhibition will give more opportunities for them to be seen by the general public including those who are not believers. You cannot force unbelievers to go to church or to read the Bible. The same is true for believers who have lost their faith, and stopped reading the bible or attending church.

Question 6: Will you be selling your biblical paintings?

Answer 6: No. God led me to paint "The Life of Our Lord" and display them in my

gallery for the purposes explained above. The 14 paintings displayed in sequence on the first level in the Pierre Bittar Museum must always be together and graciously displayed to the public. This is God's wish and I will always respect it.

Question 7: What about those who are interested in having these paintings either for public display like churches and museums or at private homes?

Answer 7: The print technology called giclee allows for the printing on canvas or other surfaces a very faithful copy of the original. This technique uses a scanner which is connected to a special computer that analyzes dot by dot each color, mixes from 4 ink containers (Red, Yellow, Blue, and Black) the right quantity of ink from each container,

until it obtains the exact color of that spot read from the original painting. By means of a special spray feature, the ink is sprayed on the white canvas on the exact spot scanned on the original painting. What is interesting to know is the copy can be in any desired size either larger or smaller than the original. Furthermore, a detail of the original can be selected and copied in the desired size.

Question 8: What will be the future of the original 14 paintings in the long term?

Answer 8: They will remain in the Pierre Bittar Museum even after I pass away until a major internationally known museum expresses interest. In this case, they will be donated to that museum with two conditions; first, that the 14 paintings must be hung together in a large display area of the museum

with the correct sequence starting with the Annunciation and ending with the Ascension, and second; that they must be displayed permanently.

Question 9: What is your biggest wish and desire?

Answer 9: To be with the Lord for eternity.

Chapter 7

Quizzes

The following two pages contain three quizzes that families can enjoy together.

Answers are below.

Quiz 1 Matching	Quiz 2 Appearances	Quiz 3 How Many
1 = C	Jesus = 13	(1) = 5
2 = N	John = 7	(2) = 4
3 = J	Joseph = 3	(3) = 5
4 = E	Angels = 3	(4) = 5
5 = M	Boats = 2	(5) = 7
6 = L	Birds = 2	(6) = 3
7 = A	The Blessed Mary = 6	(7) = 13
8 = K		(8) = 5
9 = D		(9) = 5
10 = F		(10) = 6
11 = H		
12 = R		
13 = B		
14 = P		

A

B

C

H

Quiz No. 1 Matching

Around each painting there is a letter. Indicate that letter to the corresponding title below.

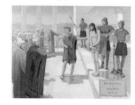

J

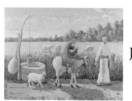

K

No.	Painting Title	
1	The Annunciation	
2	The Birth of Jesus	
3	The Flight into Egypt	
4	At the Temple	
5	The First Four Disciples	
6	The Marriage in Cana	
7	Jesus Resurrects a Widow's Son	
8	Feeding the 5000	
9	The Last Supper	
10	The Betrayal of Judas	
11	The Humiliation of Jesus	
12	Crucifixion and Death	
13	The Resurrection of Jesus	
14	The Ascension	

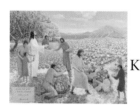

L

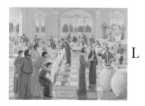

D

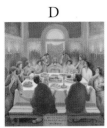

E

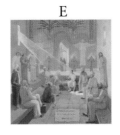

F

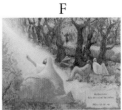

Quiz No. 2 Appearances

In how many Paintings does each of the following appear?

Jesus		John		Joseph	

Angels		Boats		Birds	

Blessed Virgin	

Quiz No. 3 How many...

1	disciples in painting 6?	
2	animals in painting 2?	
3	animals in painting 3?	
4	paintings with window light?	
5	sea gulls in painting 5?	
6	paintings with people eating?	
7	candles in painting 9?	
8	paintings with Jesus praying or blessing?	
9	paintings that are square?	
10	paintings that are rectangular?	

M

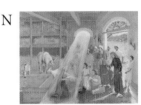

N

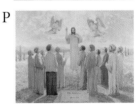

P

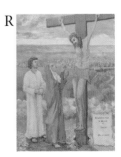

R

The Holy Trinity

Chapter 1

Introduction

Doubt is the enemy of Faith. If it is not dissipated, it will grow in our minds and destroy our faith. The best way to avoid such damage is to ask questions and seek convincing answers capable of destroying our doubt.

What is the Trinity of God?

The Christian faith is based on the Holy Trinity, which is: Father, Son, and Holy Spirit. All three are in the One and Only God. A triune God.

Human understanding and languages have difficulties expressing the beauty and immensity of the One but triune God.

The best way to explain a sophisticated subject is to use a simple example that we can understand, then develop it and adapt it gradually to the main subject matter.

Chapter 2

Inspired Explanation of the Holy Trinity

Example of 3 Candles	Illustration	God
There is one flame although there are three candles. The essence of the flame is: heat and light.		There is one God although He is a trinity of Father, Son, and Holy Spirit. The essence of God is: Love = Heat and Wisdom = Light

The 3 candles can be either one flame or can be separated, and each one will have the same essence of heat and light which is unique to the flame.

Therefore, although

the 1st candle has a flame,
the 2nd candle has flame,
the 3rd candle has a flame.

When they are unified they have only one flame.

The Holy Trinity can be unified in one God or can be separated, and each one will have the same essence of love and wisdom which is unique to God.

Therefore, although

the Father is God,
the Son is God and,
the Holy Spirit is God.

When they are unified there is only one God.

Likewise one out of the three candles can be separated. For example, a candle can be separated to warm and enlighten another room which is in darkness.

When the Son of God became human (Isaiah 9:16) *"For a child is born...and He will be called... Mighty God, Everlasting Father."* See also, the Annunciation and the Birth of Jesus paintings No. 1 and 2 in the Life of Our Lord)

This candle can then go back to the central flame and send another flame to replace it in order to maintain the warmness and the light in that room which was already prepared to quit from the darkness.

Before returning to His Father, Jesus promised to send the Holy Spirit (Advocate) in John 15:26: *"When the Advocate comes, whom I will send to you from the Father...The Spirit of truth who goes out from the Father... He will testify about me."*

Chapter 3

Bible Verses Regarding the Holy Trinity

After a good understanding of the above explanation of the Holy Trinity of God, let's read some verses from the Old Testament as well as from the New Testament in regard to the Holy Trinity of God.

In the Old Testament God has revealed Himself to us at the top of the first page as if He wanted us to understand up front who He is.

In Genesis 1:1-3:

[1]In the beginning God created the heavens and the earth [2]... and the Spirit of God was hovering over the water. [3]and God said (The Word of God), "Let there be light," and there was light.

As we can see:

God (the Father) is mentioned in verse 1,
the Spirit of God (The Holy Spirit) in verse 2 and,
the Word of God (God said) in verse 3.

<div style="text-align:center">Word of God = Jesus.</div>

When God speaks in plural using pronouns like us, our, and we, it is understood that the Holy Trinity is speaking—Father, Son, and Holy Spirt.

Some might think that the use of pronouns like us, our, and we, refer to God and His angels. This cannot be true as angels are creatures of God and not creators. So when God said, "Let us make mankind in our image," the us and the our He is referring to is certainly Jesus and the Holy Spirit, who are with Him constituting the Holy Trinity.

Let us read now some verses of the Old Testament in which God is using these plural pronouns.

Genesis 1:26: *Then God said, "Let us make mankind in our image, in our likeness, so that they may rule over the fish in the sea and the birds in the sky, over the livestock and all the wild animals, and over all the creatures that move along the ground."*

Genesis 3:22: *And the LORD God said, "The man has now become like one of us, knowing good and evil. He must not be allowed to reach out his hand and take also from the tree of life and eat, and live forever."*

Genesis 11:7: *"Come, let us go down and confuse their language so they will not understand each other."*

Isaiah 6:8: *Then I heard the voice of the Lord saying, "Whom shall I send? And who will go for us?" And I said, "Here am I. Send me!"*

In the New Testament some verses explain situations in which the Holy Trinity—Father, Son, and Holy Spirit—are mentioned together.

Matthew 28:19: *Therefore go and make disciples of all nations, baptizing them in the name of the Father and of the Son and of the Holy Spirit,*

In some other verses the presence of the Trinity appears on the scene.

Matthew 3:16-17: [16]*As soon as Jesus was baptized, he went up out of the water. At that moment heaven was opened, and he saw the Spirit of God descending like a dove and alighting on him.* [17]*And a voice from heaven said, "This is my Son, whom I love; with him I am well pleased."*

It is important to understand the Holy Trinity. Without such a good understanding some verses of the bible will be confusing. Below are some of them.

Isaiah 7:14: *Therefore the Lord himself will give you a sign: The virgin will conceive and give birth to a son, and will call him Immanuel.*

Immanuel means God is with us. (Im=with, man=us, u'al=God.)

Comment: In the above verse Isaiah called Jesus God. Now we understand why Jesus was called God (because if separated from the Holy Trinity, Jesus is God.)

Isaiah 9:6:*For to us a child is born, to us a son is given, and the government will be on his shoulders. And he will be called Wonderful Counselor, Mighty God, Everlasting Father, Prince of Peace.*

Comment: Calling Jesus everlasting Father is a confirmation that the Holy Trinity is one God having the same essence. They are in each other.

Isaiah 25:9:*In that day they will say, "Surely this is our God; we trusted in him, and he saved us. This is the LORD, we trusted in him; let us rejoice and be glad in his salvation."*

Comment: Beside being called God and Lord, Isaiah called Jesus a Savior.

Isaiah 40:3:*A voice of one calling: "In the wilderness prepare the way for the LORD; make straight in the desert a highway for our God."*

Comment: Isaiah was predicting John the Baptist announcing the arrival of Jesus.

John 1:1-5: *[1]In the beginning was the Word, and the Word was with God, and the Word was God. [2]He was with God in the beginning. [3]Through him all things were made; without him nothing was made that has been made. [4]In him was life, and that life was the light of all mankind. [5]The light shines in the darkness, and the darkness has not overcome it.*

Comment: At the beginning of his Gospel John spoke about God the Father and God the Son. He called Jesus the word because without the word nothing was made. ("Let it be," He spoke and it was. - see Genesis.) Isaiah also called Jesus the light which also means wisdom.

John 10:30: *I and the Father are one.*

Comment: This is another confirmation of the Holy Trinity in one God. It also confirms what Isaiah had said, "Jesus is the everlasting Father."

John 14:6: *Jesus answered, "I am the way and the truth and the life. No one comes to the Father except through me.*

Important Note: This message is for those who believe in God but not in the Holy Trinity of God. Without Jesus there is no Holy Trinity, therefore there is no God. (If this is not yet clear please go back to the explanation of the Holy Trinity explained above.)

John 14:8-11: *[8]Philip said, "Lord, show us the Father and that will be enough for us." [9]Jesus answered: "Don't you know me, Philip, even after I have been among you such a long time? Anyone who has seen me has seen the Father. How can you say, 'Show us the Father'? [10]Don't you believe that I am in the*

Father, and that the Father is in me? The words I say to you I do not speak on my own authority. Rather, it is the Father, living in me, who is doing his work. ¹¹Believe me when I say that I am in the Father and the Father is in me; or at least believe on the evidence of the works themselves."

Comment: Jesus made it very clear about the Holy Trinity of God. He emphasized the fact that His coming among us was also to reveal to us the hidden and invisible God.

To conclude this very important subject of the Holy Trinity please read carefully what God has testified in the following verses of John.

1 John 5:11-13: *¹¹And this is the testimony: God has given us eternal life, and this life is in his Son. ¹²Whoever has the Son has life; whoever does not have the Son of God does not have life. ¹³I write these things to you who believe in the name of the Son of God so that you may know that you have eternal life.*